MIDDLEWICH & HOLMES CHAPEL

THROUGH TIME

Paul Hurley

AMBERLEY PUBLISHING

Acknowledgements

I would like to thank Matt Wheeler of the Weaver Hall Museum and Workhouse, Mike Eddison of the Chester Records Office, Lillian Platt, Geoffrey and Delia Wakefield and David Griffiths for their kind permission to allow me to use old photographs from their collections. I also thank Chris and Joan Riley, Pat Pugh of the Parish Centre, the Reverend Ian Bishop and the superb local historian Tony Bostock for their help and advice. Also David Cowgill of Holmes Chapel Parish Council, David Morgan of the *Winsford and Middlewich Guardian*, Ray Pottle (whose father was station master at Holmes Chapel). Martin Thomson of www.holmeschapel.org.uk, and Russell Bairstow and of course my patient wife Rose who allowed me the not inconsiderable time that it took to compile this book. All of the modern photographs were taken by the author.

First published 2010

Amberley Publishing
Cirencester Road, Chalford,
Stroud, Gloucestershire, GL6 8PE

www.amberley-books.com

Copyright © Paul Hurley, 2010

The right of Paul Hurley to be identified as the
Author of this work has been asserted in accordance
with the Copyrights, Designs and Patents Act 1988.

ISBN 978 1 4456 0199 1

British Library Cataloguing in Publication Data.
A catalogue record for this book is available from
the British Library.

Typeset in 9.5pt on 12pt Celeste.
Typesetting by Amberley Publishing.
Printed in the UK.

Introduction

Middlewich

Middlewich is an ancient market town situated at the confluence of the rivers Wheelock, Croco and Dane. It is one of the Wiches, joining Northwich and Nantwich from which salt has been drawn for centuries, in fact it is the middle of the two other Wiches, hence the name. The Romans were the first to discover the brine that flowed freely here and founded the town calling it Salinae after the salt. From the traces of a Roman road in the vicinity there is little doubt that it was a Roman station and the remains of an entrenchment camp were discovered at Kinderton.

As well as the importance of the town during the Roman period, it also featured in the English Civil War when two battles took place here with the church as a centrepiece; they were titled the 1st and 2nd Battle of Middlewich, between the Royalists commanded by Sir Thomas Aston, and the Parliamentarians commanded by Sir William Brereton. Reading the description of the 1st battle in a letter from Sir Thomas to Lord Cholmondeley on 17 March 1642, it would appear to have been quite a badly managed affair like so many in that war. On one occasion the Royalists crowded into the church leaving a cannon in the graveyard to fight off troops coming from all directions, especially down Dog Lane, now Queen Street. Sir Thomas wrote; 'I found all the foote wedged up in the church, like billets in a wood pile, noe. one man at his arms.' The noble knight is scathing about his incompetent and mutinous troops but managed to escape himself via Kinderton! Those in the church were shot or captured including Sir Edward Moseley and other officers, 400 common soldiers and weapons for 500 men. When describing the first battle Sir William Brereton quoted 'God hath not given many more complete victories'. In the 2nd battle about 9 months later Sir William suffered his only major defeat in the war when the parliamentarians lost due to Royalist assistance from Irish troops. Marks on the porch still exist from the cannon shots in this battle.

The church in question is the ancient parish church of St Michael and All Angels. Parts of the structure dates from the twelfth century but most of the church was built 1480–1520 and in 1858 improvements were made including the whole of the old deal galleries, and pews were removed. The floor was lowered to its original level, all the old defective interior masonry restored, and the whole refitted with open benches. There was once an old chapel on the north side of the church dedicated to the Weaver family but this was removed during the dissolution of the monasteries.

Middlewich has seen many changes over the years, none less than the building of St Michaels Way through the town in the 1970s to free up the road to the M6 motorway. A campaign is afoot to re-open the railway station that has been closed to passengers since 1960. With the house building programme that has taken place since then, and the number of commuters who live here this should be a priority. Mention has to be made of the canal network that is centred here, the Trent and Mersey canal, the Shropshire Union canal and of course the tiny Wardle canal. And this, combined with the very popular annual Middlewich Boat Festival, make Middlewich a town frequently enjoyed by holidaymakers.

Holmes Chapel or Church Hulme

Once a sleepy village 4 miles from Middlewich and now separated by the M6 at junction 18, Holmes Chapel, or Church Hulme, as it was once called, and still is in parish records, sits astride an important crossroads. The village once resounded only to the gentle sound of horse and pedestrian traffic passing through, and in the days when meat had to be delivered in its live state drovers frequently passed along the roads, driving before them their beasts for market. Stopping places were needed to enable the men to refresh themselves and ancient inns served the purpose well. The Swan Inn on the Knutsford Road catered especially for this traffic and in the village the Red Lion, George and Dragon and Bulls Head cared for a more upmarket clientele delivered regularly in the coaches that travelled the country. Coaches that had romantic names like *The Express, The Aurora* and – *The Bang Up!* Then along came the railways and Holmes Chapel station was opened with a pub alongside it called The Swan, later to be called The Swan Inn when the one on Knutsford Road returned to farming.

Where Middlewich housed the Nestlé Condensed Milk Factory, Holmes Chapel could boast the large and impressive complex of the Benger's Company. Who can remember their food for night time drinks and invalids? The impressive premises are still there just the other side of the Iron Bridge but at the time of writing are closed. Also in the village is the Fine Art Wallpaper Factory or FADS situated at the huge Victoria Mills adjoining the railway – wallpaper has been made here since around 1912. For a relatively small village Holmes Chapel has seen its fair share of heavy industry.

Then there is the church, situated in the centre of the village the parish church of St Luke dates from around 1430 when it was a simple wooden chapel of ease built with the sandstone tower. Later on it was encased in or replaced with brickwork but the original wooden pillars and roof can still be seen inside. This brickwork saved the church in 1753 when fire swept through the village destroying all but the Red Lion, the church and the two cottages at the rear of it.

Two small towns in Cheshire's green and pleasant land but both steeped in history and a pleasure to visit whether it is by canal (at Middlewich), road, or rail (at Holmes Chapel)! So enjoy this book and reminisce about how they once were compared with what we have now.

About the Author

Paul Hurley is a freelance writer and member of the Society of Authors. He has a novel, newspaper, magazine and book credits to his name and lives in Winsford, Cheshire with his wife. He has two sons and two daughters.

By the same author

Fiction
Liverpool Soldier

Non-Fiction
Middlewich (with J. Brian Curzon)
Northwich Through Time
Winsford Through Time
Villages of Mid Cheshire Through Time
Frodsham and Helsby Through Time
Nantwich Through Time
Chester Through Time (with Ken Morgan)

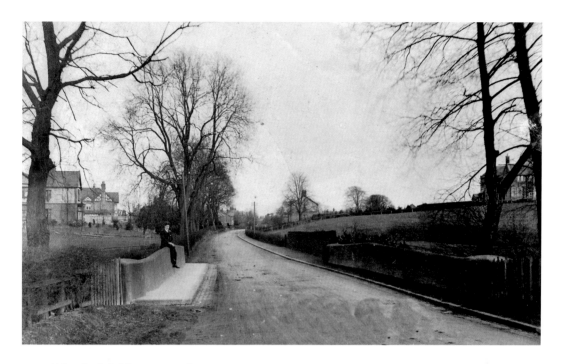

Wheelock Bridge 1911 and 2010

This bridge is situated on the road from Winsford to Middlewich as one enters the latter and it carries the road over the small (most of the time) River Wheelock. This view is towards the town and I did not stand in exactly the same place as the photographer who took the 1911 photograph. The traffic now is far too heavy!

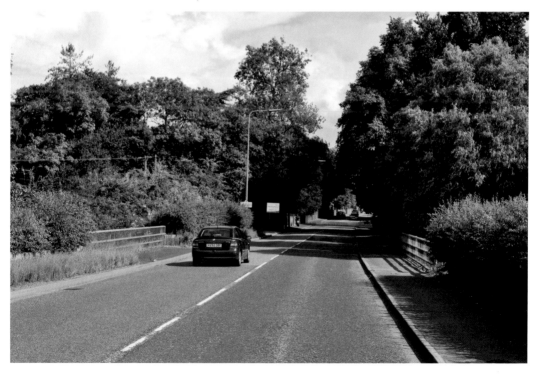

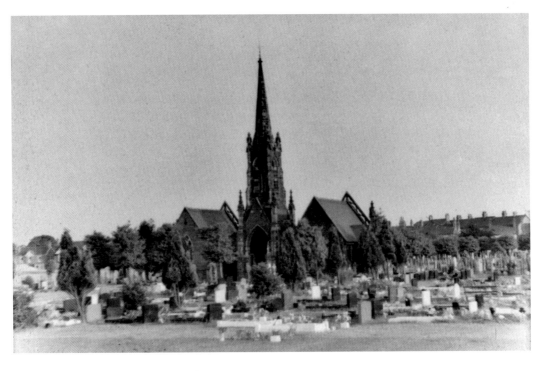

Middlewich Cemetery Undated and 2010
Middlewich cemetery, in the area known as Newton, contains two mortuary chapels as seen in the photographs. One chapel was for Church of England followers and the other for 'Dissenters.' It was formed in 1867 and only one of the chapels is now used for the purpose that it was built. Note that some of the small ornamental spires have gone from the roof.

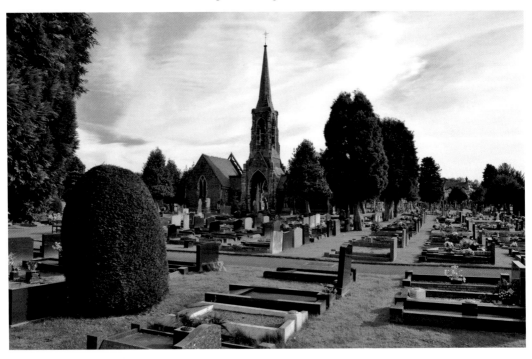

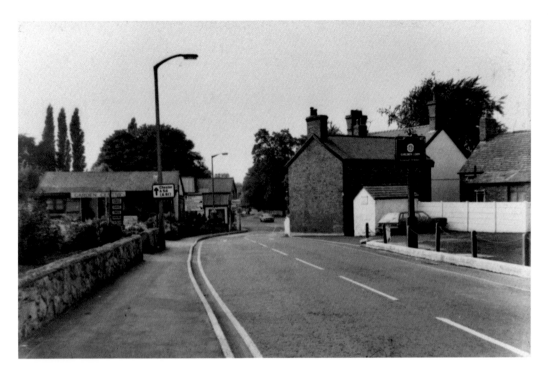

Golden Lion Rear 1970s and 2010

Newton Way is now in the one way system, the frontage of the Golden Lion is opposite the cemetery and on the left is Boosey's nursery. This business is of long standing having been set up in 1860 by William Boosey who was once a gardener at Chatsworth House, although the premises had been involved in gardening requisites since 1787.

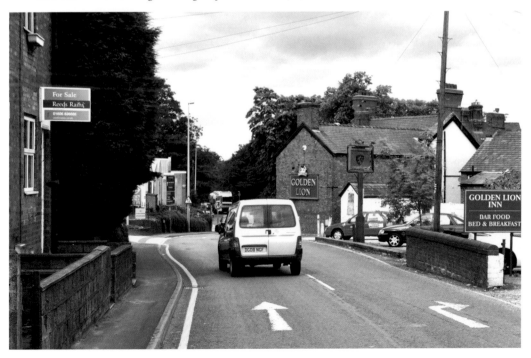

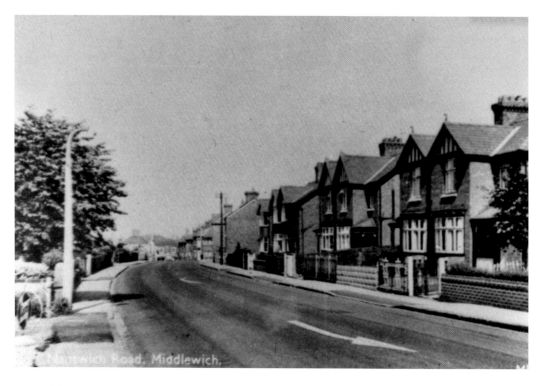

Nantwich Road 1960s and 2010
Nantwich Road leaves the town and wends its way to Nantwich, passing under the canal as it does. The houses here are of the more prestigious variety built near to the town between the wars.

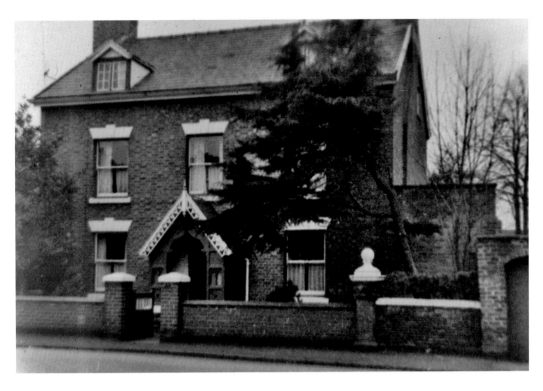

Large House St Anne's Road Undated and 2010
This house situated in St Anne's Road is an example of the better quality of housing in this area; it is interesting to see the charges that have taken place over the last forty to fifty years.

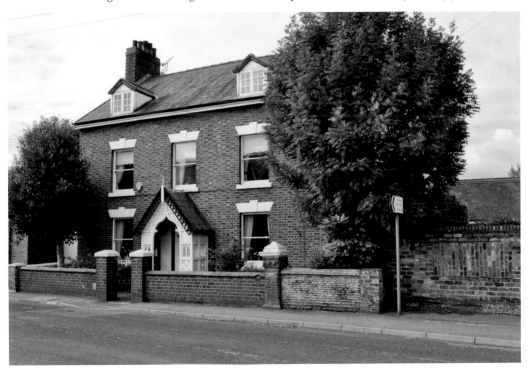

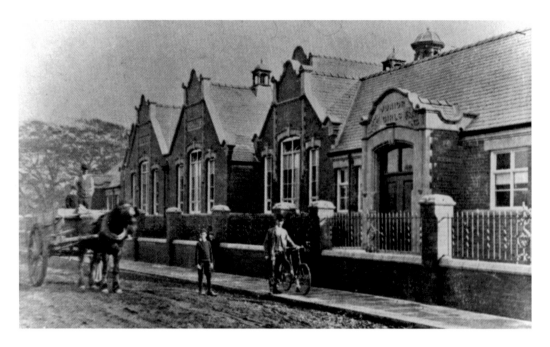

Middlewich Council Schools 1906/10 and 2010

This school was opened on the first of November 1906 and catered for children aged seven to fourteen. In 1979 it became the Middlewich County Comprehensive and this building is still used in education. However there has been much re-development at the rear to bring the school up to date. It is situated in King Edward Street.

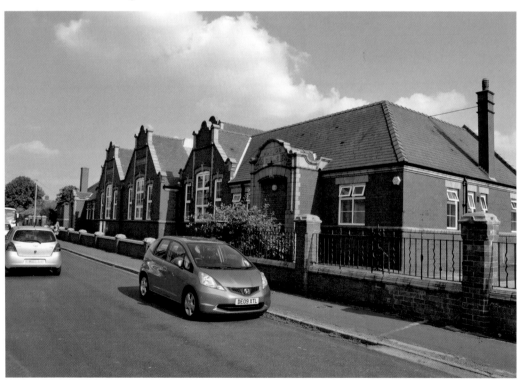

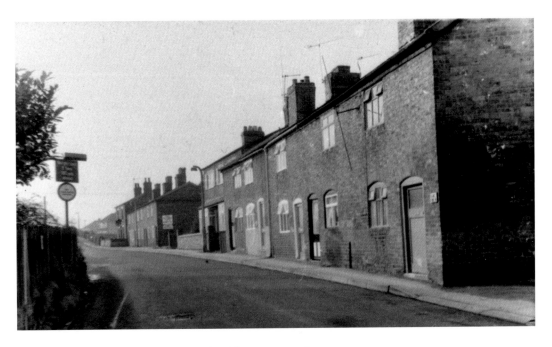

Sutton Lane Towards the Canal Bridge 1970s and 2010
This is the start of what was originally a long road leading from Lewin Street to Nantwich Road but with re-development in the area it has been shortened. It is interesting to see the minor changes that have taken place over the years. The road approaches the bridge that can be seen in the distance crossing the Shropshire Union canal.

Sutton Lane Reverse 2010 and 1970s
We now continue along Sutton Lane and just before crossing the bridge we look back towards Lewin Street. The large house in the foreground has had the wall exchanged for a wooden fence and the cottages have gained porches.

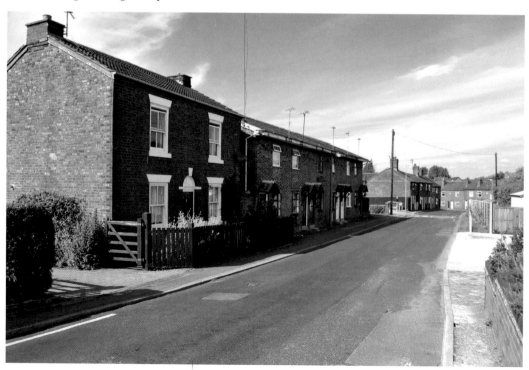

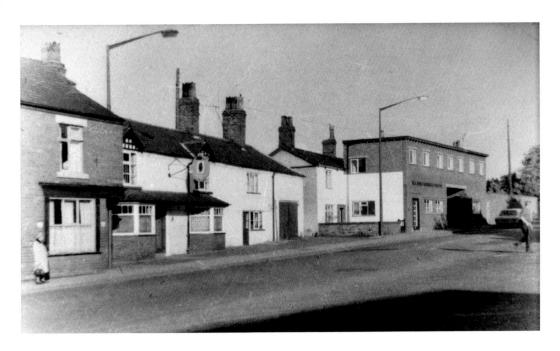

Cheshire Cheese Public House 2010 and 1970s
This ancient pub is one of the Middlewich canal pubs that could be accessed from the canal at the rear. The part of the pub at the far end was once a cottage in which an old lady lived. It was later amalgamated into the pub. The Cheshire Cheese was a favourite of the Middlewich Home Guard during the war and their rifles would be stored behind the bar as they refreshed themselves. On one occasion one of the guns was discharged firing a bullet through the bar and into the floor in the back room.

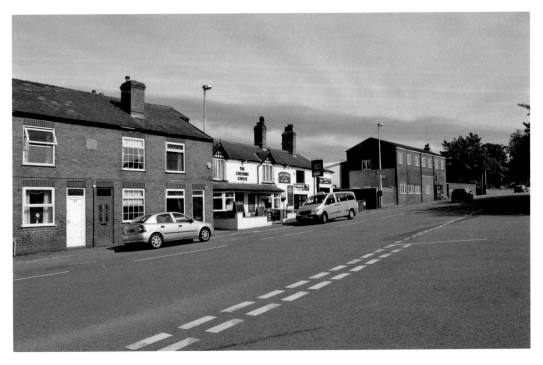

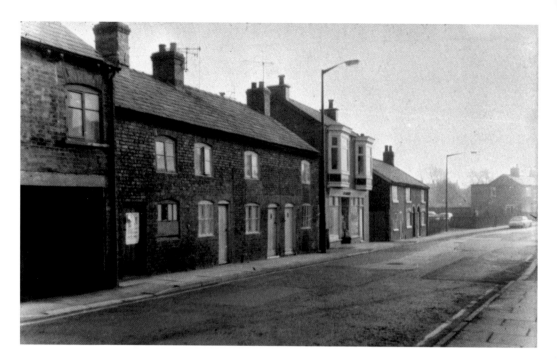

Lewin Street 1970s and 2010

Here we look along Lewin Street towards Sandbach and past the unusual house with bay windows on the second floor. In the 1970s photograph the house was a shop and in the modern photograph it has been converted into a single dwelling house. During the Middle Ages Lewin Street was the main street in Middlewich. Many buildings have been swept away here and some have been replaced, others have just been replaced with a boundary wall.

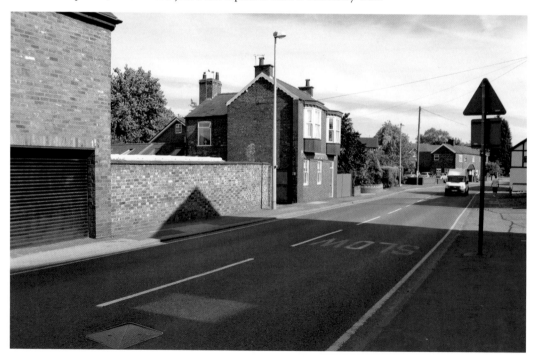

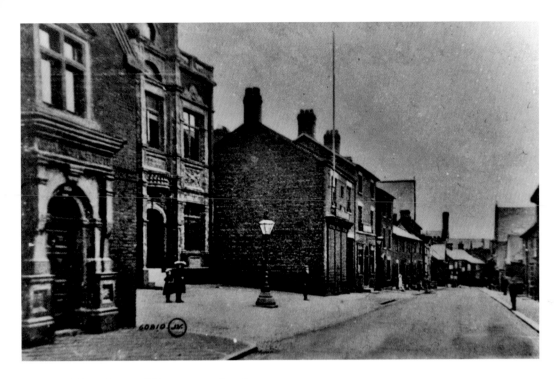

British Legion Building 2010 and early 1900s

The large red brick building in Lewin Street was built in 1897 on the site of Naylor House. It was then the Victoria Free Library and Technical Schools and was opened by the Earl of Crewe. It now houses the Middlewich British Legion and assorted Council and other offices. The area at the front was once known as Victoria Square.

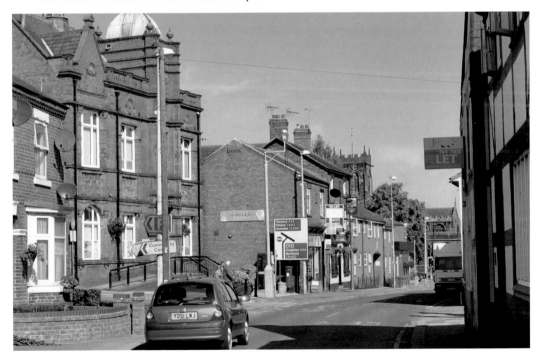

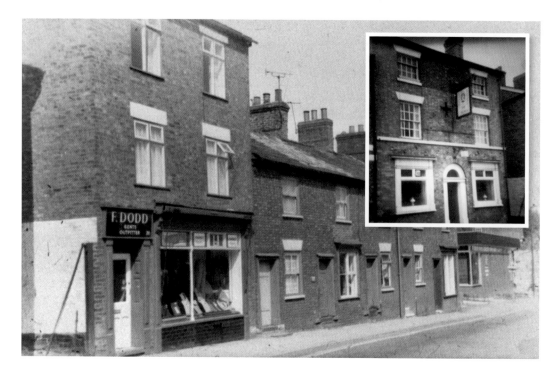

The Crown, now The Narrowboat 1960s and 2010

This old pub was once called The Crown but towards the end of the last century the name was changed to The Narrowboat as a tribute to the nearby canal. It is now a successful business bucking the trend somewhat in the downturn in fortunes for public houses. The old photograph shows Dodd's Gents Outfitters which was next door to the pub and has now been demolished. The inset shows the pub as it was and the corner of Dodd's shop.

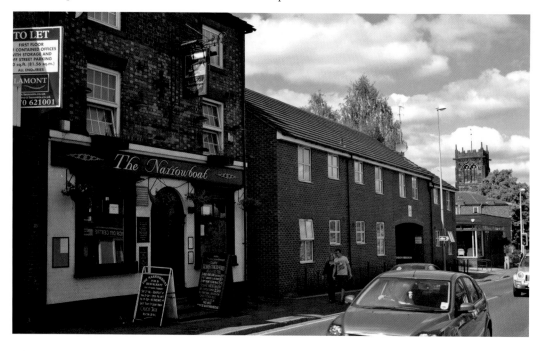

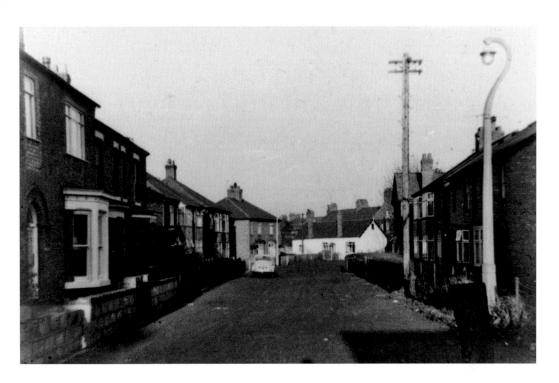

Lawrence Gardens 2010 and 1960s

This short road once went between Wheelock Street and Webb's Lane but is now dissected by St Michael's Way. The houses in the distance are now on the other side of the dual carriageway. It was named after Charles Lawrence, clerk of the council and local historian, who found a Neolithic stone Celt when the Gardens were being built. It was this that created his interest in historical research. Other Palaeolithic artefacts were found and they are now in the Grosvenor Museum at Chester.

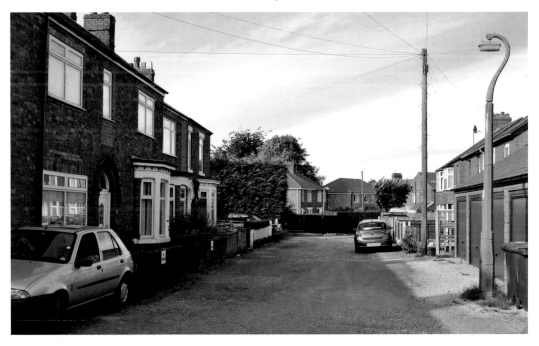

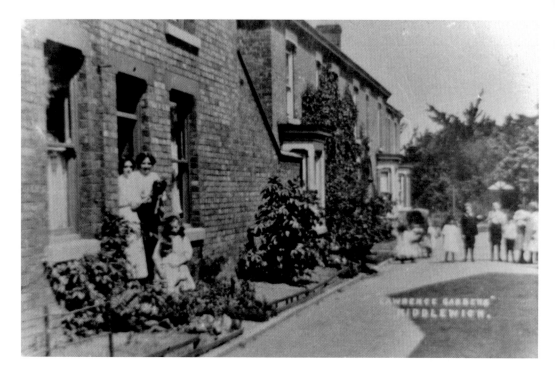

Lawrence Gardens 1920 and 2010

We now take another look along this quiet street before the dual carriageway arrived to cut it in two. Note the changes to the building on the left. In the old photograph it was a cosy house with the people in period dress standing in the doorway. In the 2010 photograph it has been incorporated into a business in Wheelock Street.

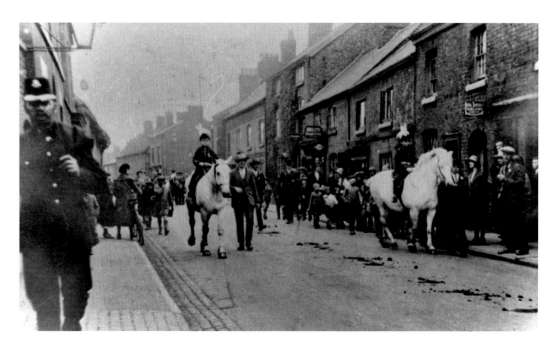

Parade Wheelock Street 1910/20 and 2010
This parade approaches the Nantwich end of Wheelock Street in the early part of the last century and shows two boys on white horses – the policeman on the extreme left wears a shako helmet. Note that the buildings on the right have altered only cosmetically over the years and the ivy has gone from the taller building.

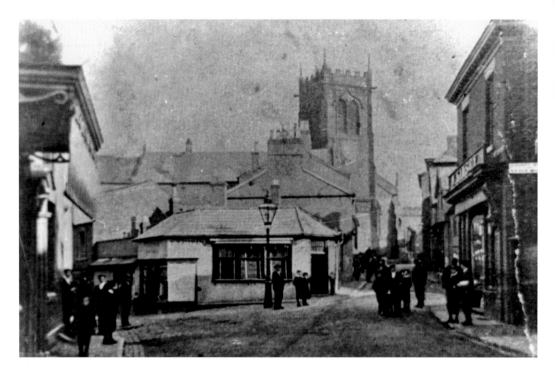

Towards Hightown 1920s and 2010

This old 1920s view looking down Wheelock Street and into the Bullring shows just how built up this area once was. Kinsey's store can be seen at the end. In the Bullring proper the shop (that is seen on the next page) is no longer Lees' butcher's but has then been taken for another use, possibly the Westminster Bank which it was at one time. Soon this building would go to make way for the war memorial that was erected in the 1920s.

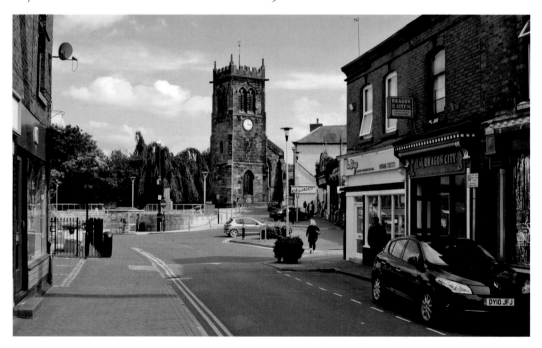

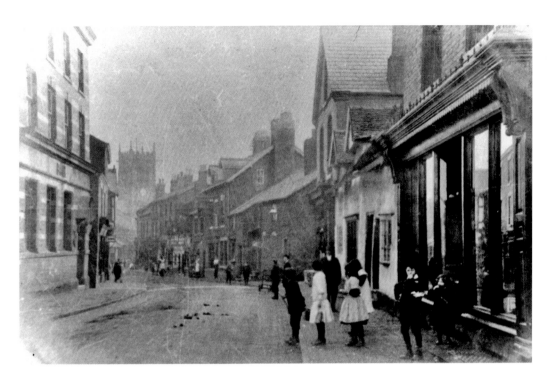

Wheelock Street 2010 and 1900s

This very old photograph taken during the very early 1900s or even late 1890s gives a view towards the Bullring. The large building on the extreme left was a bank and still is today, being a branch of Barclays. The young boys are standing where the Alhambra was later to replace the old building that can be seen. The traffic here has increased somewhat despite being only one way.

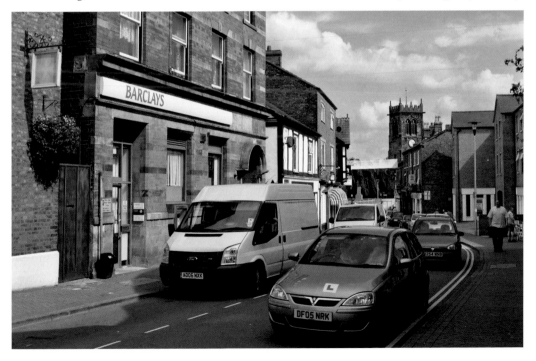

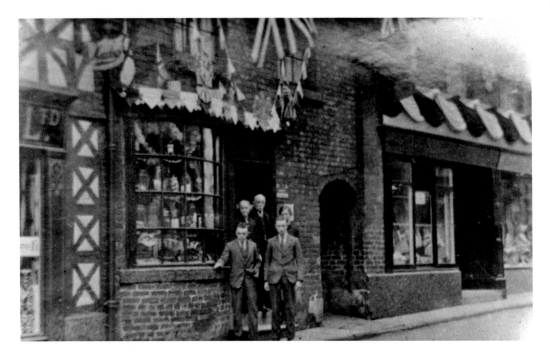

Cauley's Sweet Shop Wheelock Street 1936/1952 and 2010
This close up of the long standing shop which in 1880 and 1934 was listed as Samuel Cauley, Grocer etc, 19 Wheelock Street. Cauley is probably the old man in the photograph. In 1902 and 1906 it was Hannah Cauley, grocer and provision dealer and dealer in British wines. Towards the end of its existence it was better known as Mrs Cauley's sweet shop. The shop was demolished with those next door and was replaced with the modern shops and flats that are there now. The shop is decorated for a coronation.

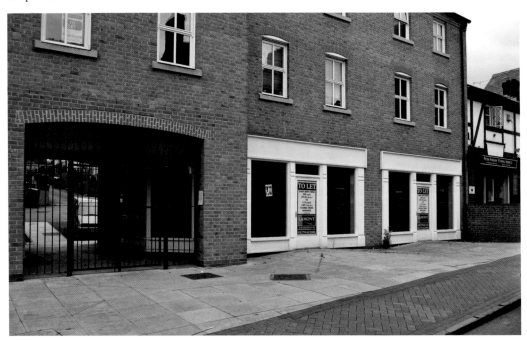

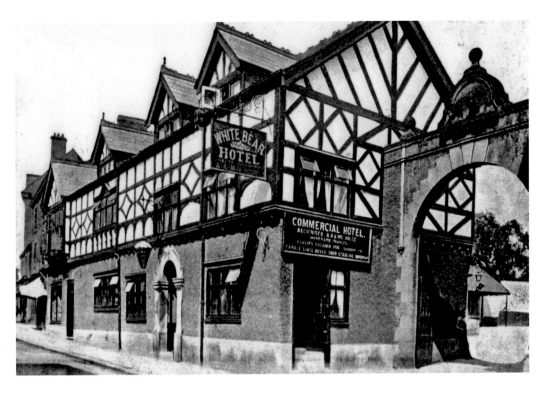

White Bear Early 1900s and 2010
The old photograph of this once popular hotel brings home the problems in the industry; it is now for sale having seen a number of tenants recently try unsuccessfully to make a go of it. Harry Bernard was the licensee in 1902 but the building is very old. The black and white cladding was erected during the Victorian period.

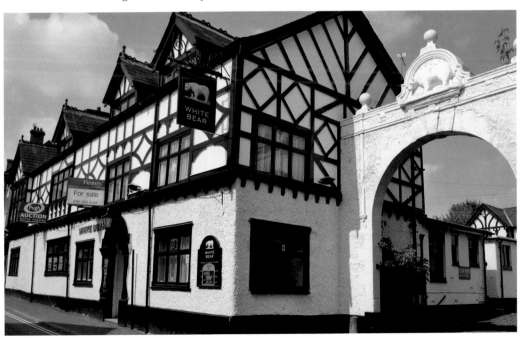

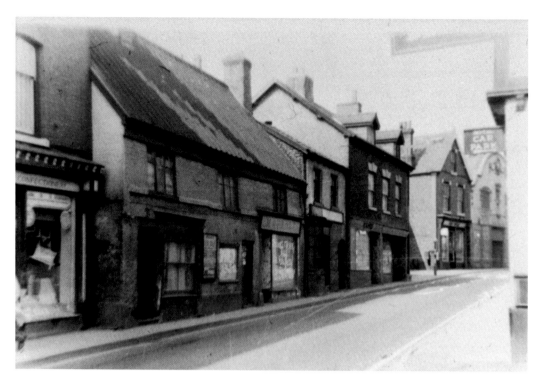

Towards Alhambra 2010 and 1960s/70s

This photograph was taken just prior to the demolition of the buildings on the left; Cauley's sweet shop can be seen as it has the shallow bay. Although the loss of these buildings was sad, the condition of them was quite poor.

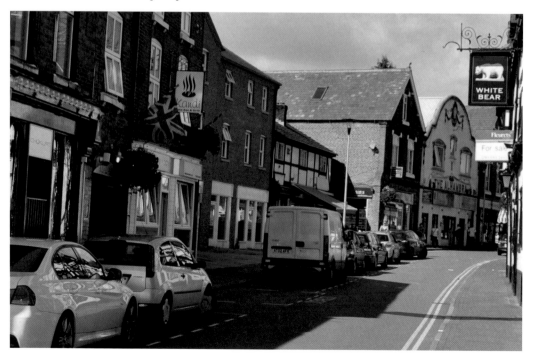

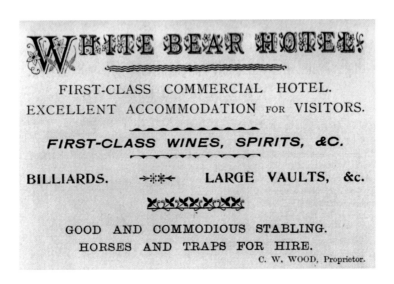

WHITE BEAR HOTEL.

FIRST-CLASS COMMERCIAL HOTEL.
EXCELLENT ACCOMMODATION FOR VISITORS.

FIRST-CLASS WINES, SPIRITS, &C.

BILLIARDS. LARGE VAULTS, &c.

GOOD AND COMMODIOUS STABLING.
HORSES AND TRAPS FOR HIRE.

C. W. WOOD, Proprietor.

White Bear 1920/30 and 1906 Advert

Another look at this old pub and the old photograph is accompanied by a period advert from 1906. Over the road was the Bull's Head hotel and further along The Black Bear hotel. At this end of Wheelock Street was the Bullring and here up until the mid 1800s bear baiting took place. An old local poem goes:

Scarce any man ever went sober to bed,
'Tis quite dreadful to think the lives they all led,
At that time in Cheshire no fun could compare
With the sport of all sports, namely, baiting the bear,

One of the pubs in Wheelock Street was the Red Cow and it was in this hostelry that the bear known as Bruin would be taken and would enjoy a drink. Other politically incorrect fun was to be had in the town on 11 October, this being the Festival of the Patron Saint. There was much riotous conduct and drinking with sports such as bull, bear and badger baiting, cock fighting, donkey races and smoking and tea drinking matches. 'A bull feight in one field and a Mon feight I' th' next.' The parson would sometimes officiate as referee at these fun and games and the favourite dish was Furmity, an ancient dish made primarily from boiled, cracked wheat.

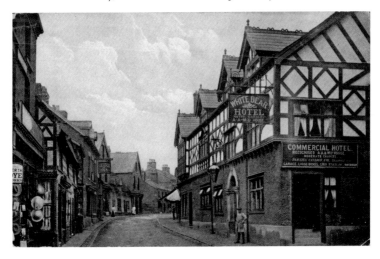

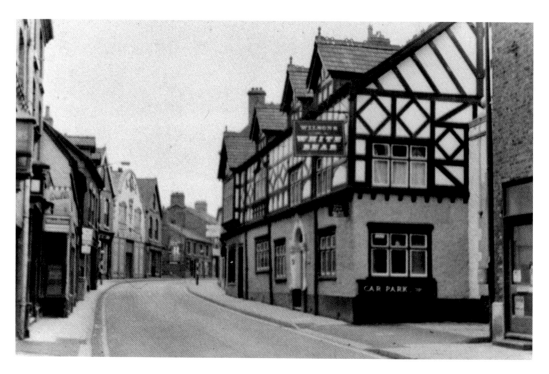

White Bear 1950s/60s and 2010

A last look at the White Bear, so much a part of Middlewich life for so long and now unoccupied, by the 1950s some alterations had taken place. You can see that the door and small window in the gable end have been replaced with a larger window.

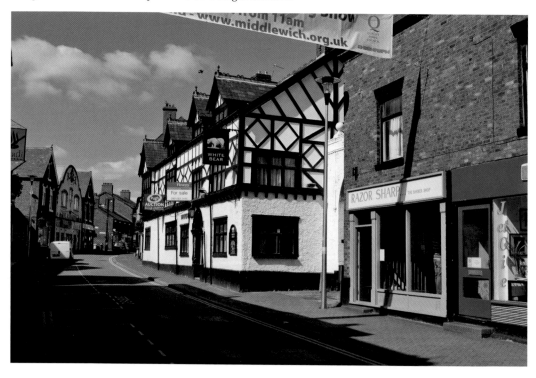

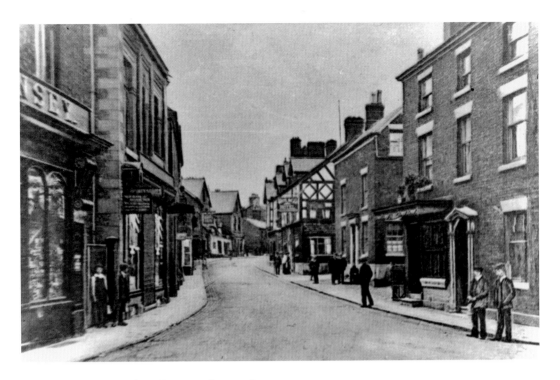

Towards Alhambra Site 1920s/30s and 2010

This old photograph was taken just prior to the demolition of the existing buildings and the building of the Alhambra seen in the modern photograph. Note that the side window on the White Bear gable end has been widened after the last photograph of it was taken.

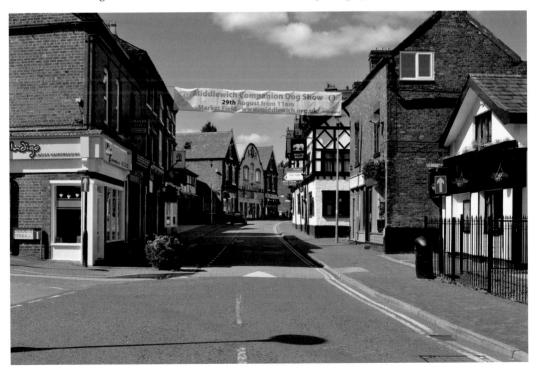

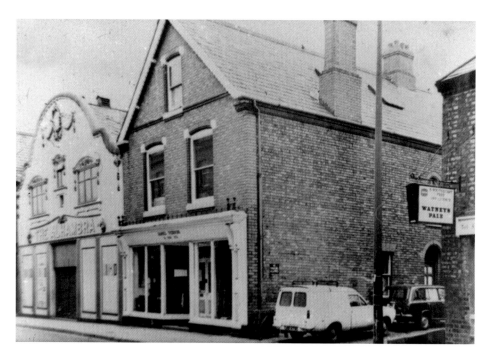

Alhambra 2010 and 1970s

Built originally as a cinema during the 1930s the Alhambra was owned by Sandbach Cinemas Ltd, and there were two performances each night. Prices were 7*d* to 1*s* 5*d*. A highly decorated front elevation in the rather loud style of cinemas built over the period can be seen. It is now a Chinese restaurant.

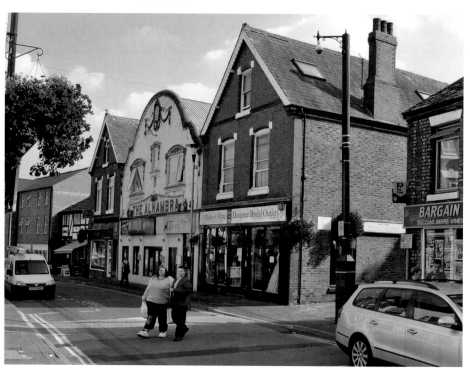

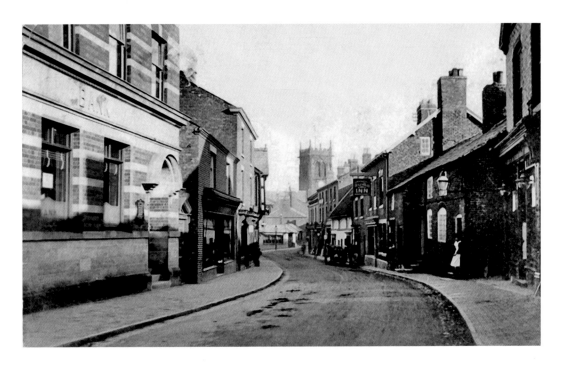

Barclays Bank Building early 1900s and 2010

This old photograph is filled with period charm and looks into the old Bullring with the buildings that were once situated there. The Bulls Head pub can be seen on the right. This was one of the buildings that was demolished and replaced with a similarly shaped new one a short while ago. We will look in more detail into the Bullring shortly. Note the single storey building next to the bank. It has been altered with faux black and white with beams.

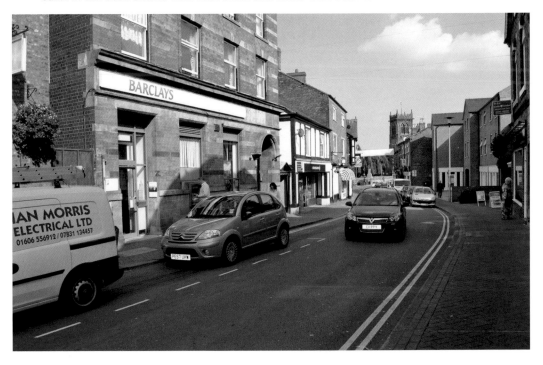

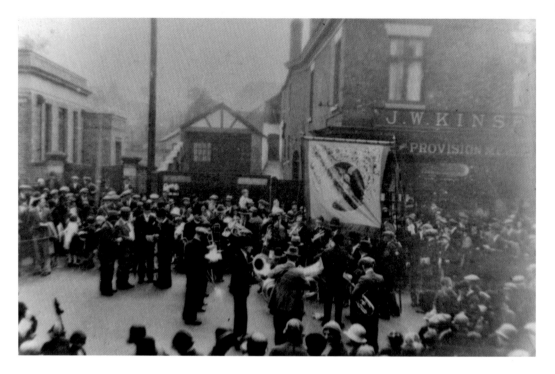

Kinsey's Store 1920s and 2010

This ancient store was situated at number one Wheelock Street and although the business did not exist in 1880, by 1902 it did and was listed as a grocer and corn dealer with another branch in Lower Street. These first buildings in Wheelock Street went during the redevelopments and road widening and the vacated area is now the entrance to a re-aligned Dierden Street.

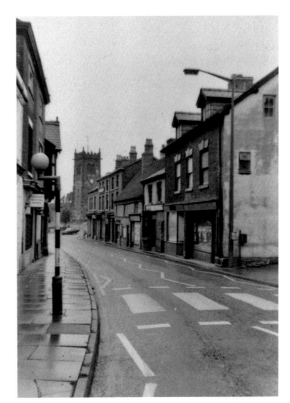

Lower Wheelock Street 1970s and 2010
This later view towards the Bullring was taken in the 1970s and we can see that the last two buildings including Kinsey's shop have gone, but the buildings which included the aforementioned Cauley's sweet shop are still *in situ*, although they appear closed and awaiting the demolition man.

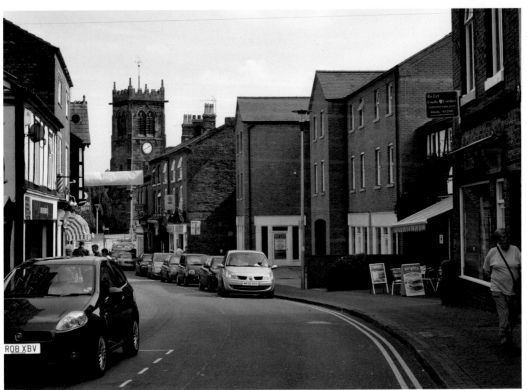

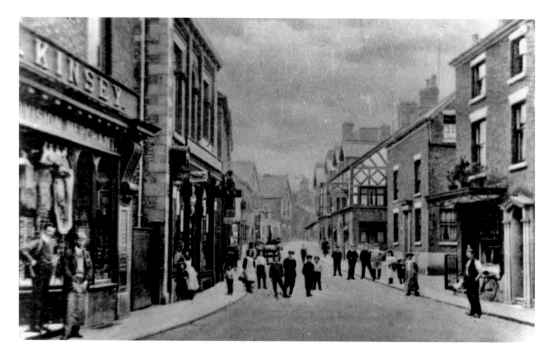

Into Wheelock Street 1920s and 2010

This old photograph taken during the 1920s shows the road filled with people eager to be photographed. The two large buildings on the extreme left, including that of William Kinsey, have now been demolished and the third building is the one that can be seen in the modern photograph. The first large building on the right has also gone. An idea of the date can be gained from the window on the gable end of the White Bear which is a window, not a door.

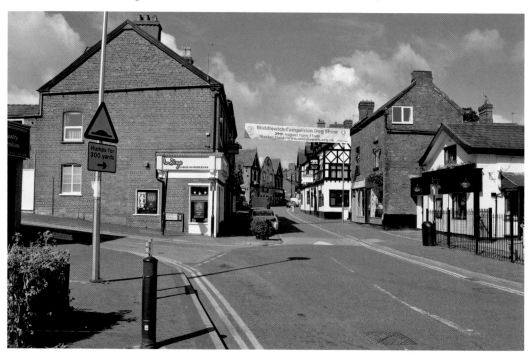

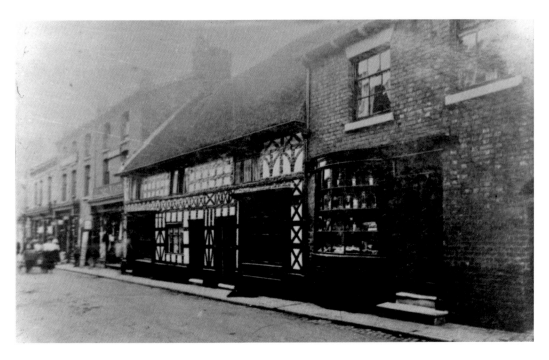

Old Shops Wheelock Street 2010 and late 1800s early 1900s
A last look at these long demolished old shops, the mark on the gable end of the first tall building that has been left by the old black and white building can be plainly seen in the new one. Cauley's sweet shop is again on plain view. This shop is remembered fondly by Middlewich residents of a certain age.

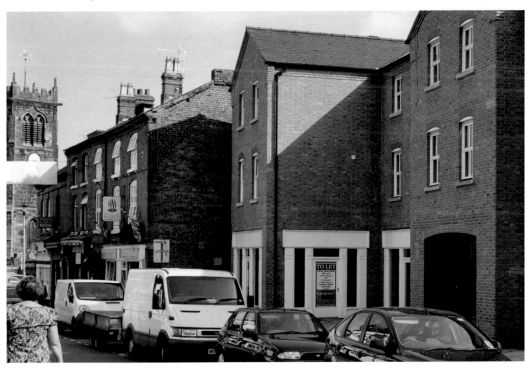

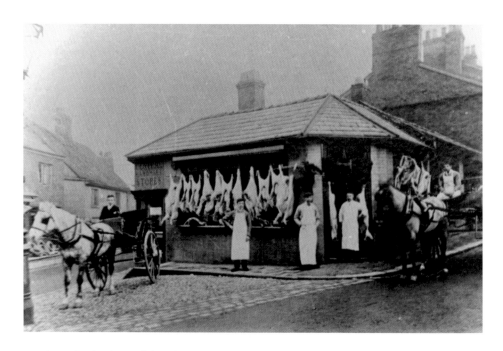

Lees' Butcher's, the Bullring, late 1890s and 2010

This butcher's shop is typical of those at the turn of the last century and later. The meat is displayed in a most unhygienic way hanging from the front of the building. The road on the left is Leadsmithy Street and the man on the trap poses for the camera. The pony and trap on the right will be for meat delivery by the butchers. The building spent some time as a bank but was demolished when the war memorial took its place. The building at the rear of it was the Carbineer public house but by 1934 had become F. Brauer's chemists and opticians. The whole area is now the amphitheatre.

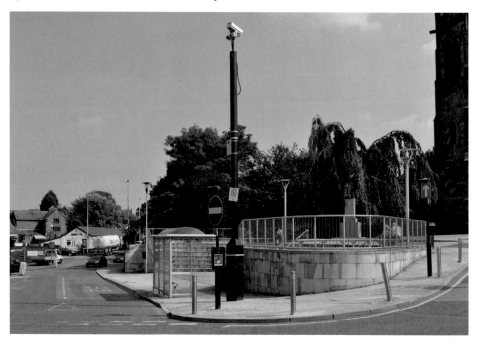

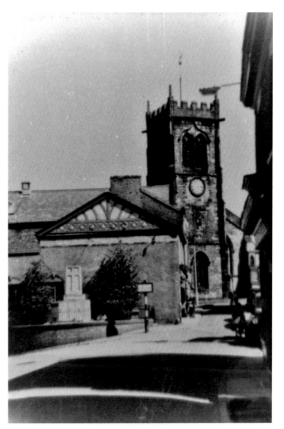

Bullring and Hightown late 1920s early 1930s and 2010

Another look at what was originally on the site of the new amphitheatre after the war memorial had been erected. This was a busy area with the chemist's, butcher's and earlier the Carbineer Inn, now it is simply a public area and Hightown is a one way street leading through to Leadsmithy Street.

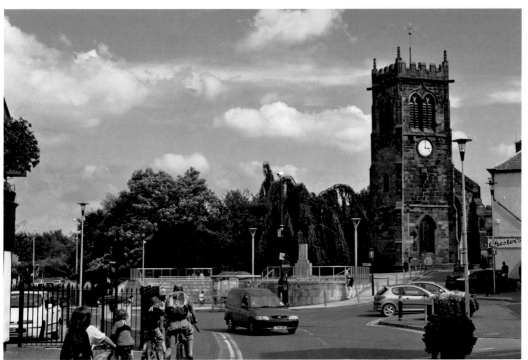

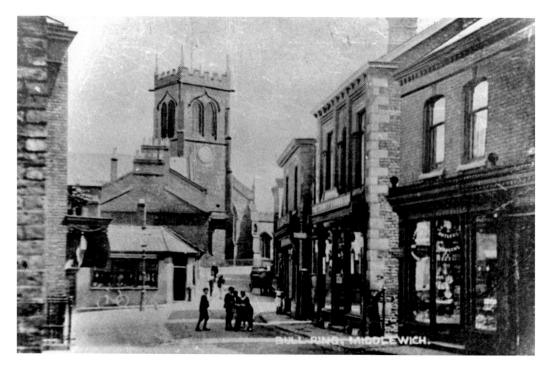

Into Hightown 2010 and early 1900s

The shop in the Bullring is still a butcher's at this time and the two now demolished buildings are still there. The gap between the buildings in the old photograph now leads to Dierden Street. Imagine this area during the English Civil War when the Royalists and Parliamentarians met here. The Royalists were outnumbered and took refuge in the church where many were killed.

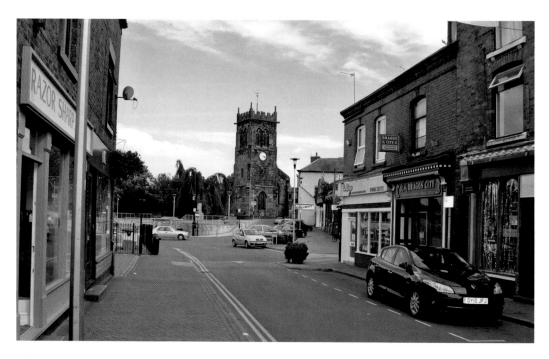

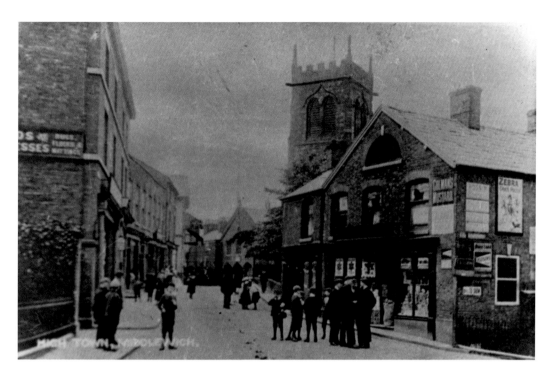

Hightown from Leadsmithy Street 2010 and 1906

Before looking further at the Bullring we will walk through Hightown to where it joins with Leadsmithy Street. As can be seen from the old photograph this was an extremely busy area. The building on the right with all of the adverts on the wall was directly opposite the shop on the extreme left. The church was surrounded by business premises but now stands alone on that side of the street. The traffic in the modern photograph shows just how busy this area is.

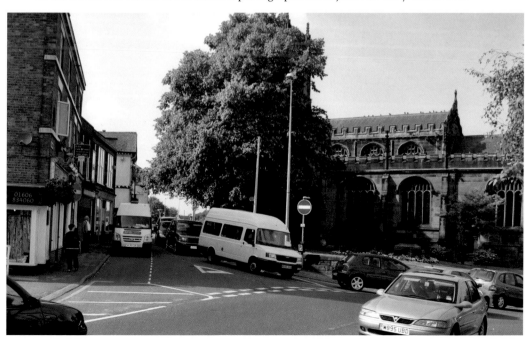

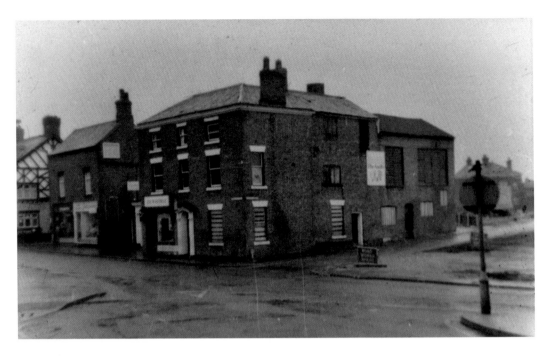

The Vaults 1960s and 2010

Now we go back to the bottom of Wheelock Street as it joins Lower Street, Pepper Street, the Bullring and Hightown and we look across at the building that was there. This building incorporated Dewhurst's the butcher's, it was demolished and replaced with The Vaults public house.

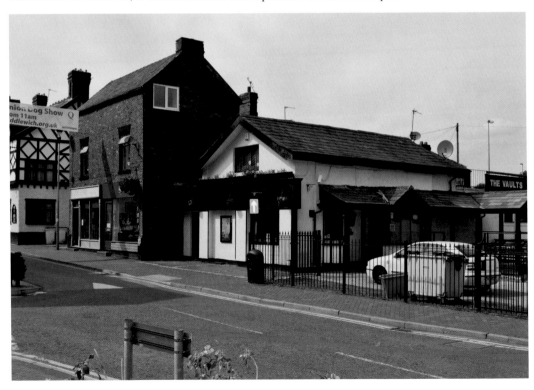

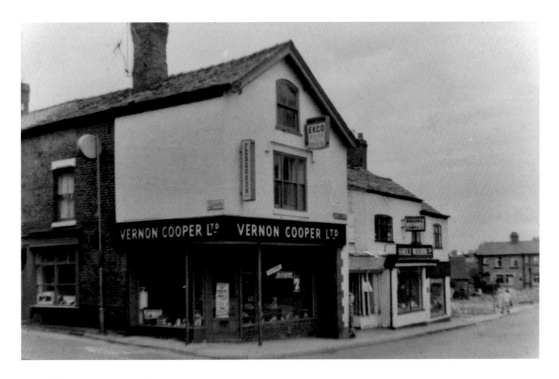

Vernon Cooper 1960s and 2010

A bit further down now to what was the junction with Lower Street, which was a continuation of Wheelock Street and Pepper Street, we see the premises of Vernon Cooper, a company selling radios and televisions. The premises once housed Jones' China Shop with Mrs Griffiths as manageress. The view is actually away from Wheelock Street down Lower Street. The whole area has now been completely transformed.

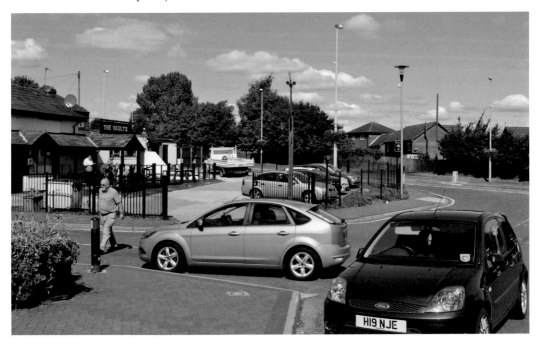

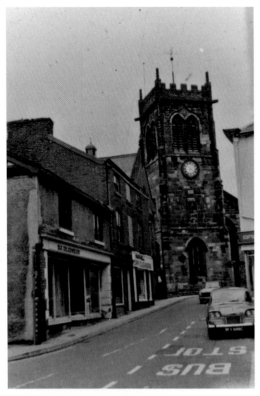

Hightown and the Church 1960s and 2010
Again we see just how busy and claustrophobic this area once was and puts into perspective the buildings that were here. The last building before the church is the Town Hall that we will see more of later. The bus stop that the Humber Sceptre is parked in illegally was outside the beautifully decorated butcher's shop which in 1902 was the premises of R. Bateman. It is now an Indian restaurant.

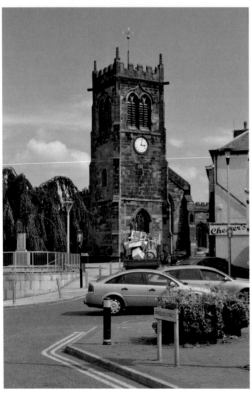

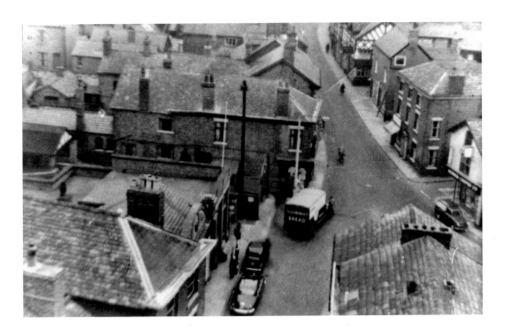

From the Church Tower 2010 and early 1960s

The old photograph taken during the 1960s but before the redevelopment took place at the end of Wheelock Street, Hightown and The Bullring. In the extreme left is the butcher's mentioned in the last caption and a Sunblest bread van is parked and making a delivery. Then we come to the 2010 photograph which was taken after the vicar, The Reverend Ian Bishop, kindly agreed to escort me to the top of the tower to take these photographs. It was exciting and extremely tiring, but the views from the top were spectacular.

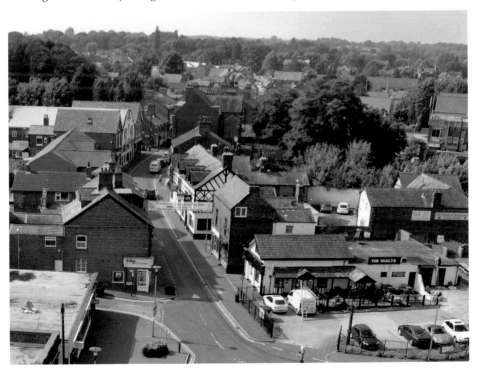

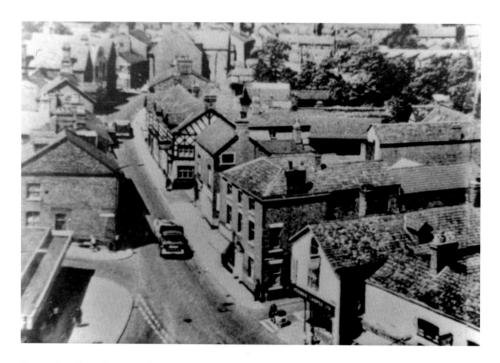

From the Church Tower late 1960s/70s and 2010

Another photograph, taken later as the Kinsey's shop and the one next door have gone and the opening into Dierden Street is there. Demolition has not started on the opposite side of the road as the Vernon Cooper store is still there. Between the taking of the two photographs, the shop next to the butcher's/Indian restaurant has been built with an overhang that is no longer there and Dierden Street can be seen. These photographs illustrate what had been there for a very long time but has now gone. Once again many thanks to the vicar who demonstrated to me just how unfit I am!!!

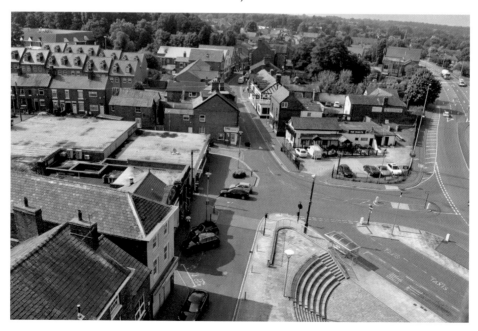

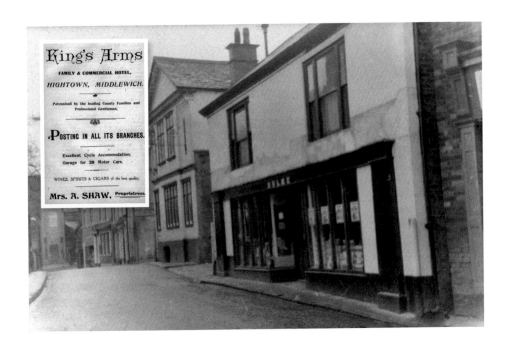

Kings Arms Undated and 2010

The Kings Arms in Hightown is one of the oldest pubs in Middlewich; the lane at the side leads through to St Anne's Road and is a continuation of King Edward Street. It was in days of yore called Dog Lane, presumably because of the dog leg shape. During the reign of Queen Victoria it was re-named in her honour as Queen Street.

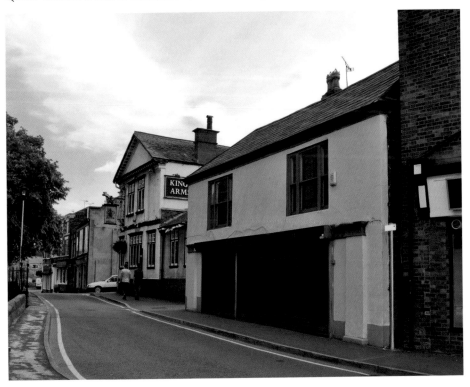

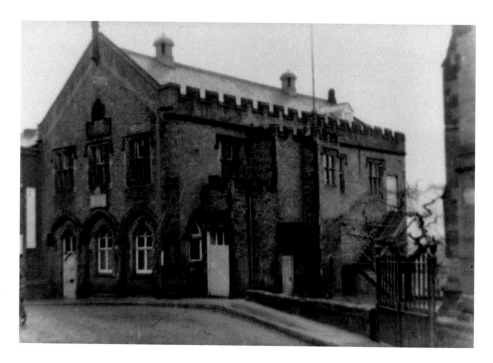

Town Hall and Market House Undated and 2010

This old photograph of the Town Hall is undated but is probably the late 1960s taken shortly before it was demolished; it was built in 1844 and paid for by James France Esq. The building was constructed in the Gothic style to fit in nicely with the church next door. The Hall, when built, also housed the Middlewich Savings Bank established in 1837, the Literary & Scientific Institute, the library and other purposes. A Petty Session was held there every month and the lower part of the building housed the Buttermarket.

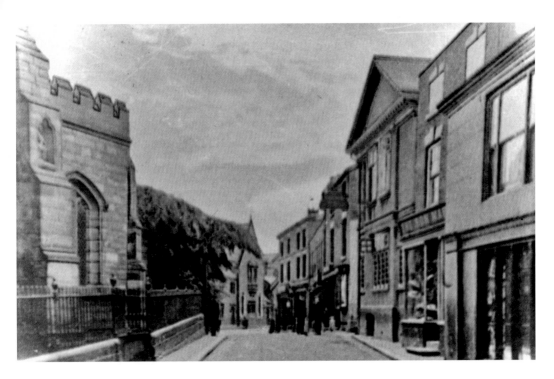

Kings Arms 2010 and Early 1900s

Another look up Hightown and in this old photograph, taken at the turn of the last century, we see some old men standing outside the Kings Arms. In 1860 this pub was also the Inland Revenue office and the landlady was Frances Earl. As can be seen, there was once a building housing a shop between the two storey one – in the new photograph – and the pub.

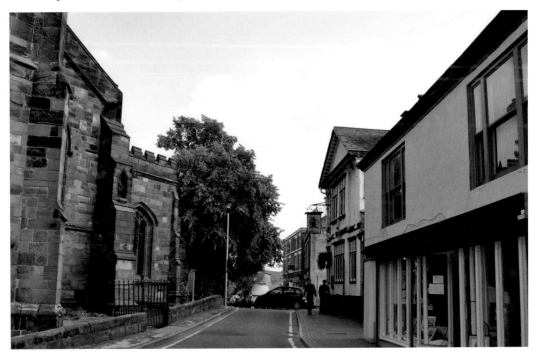

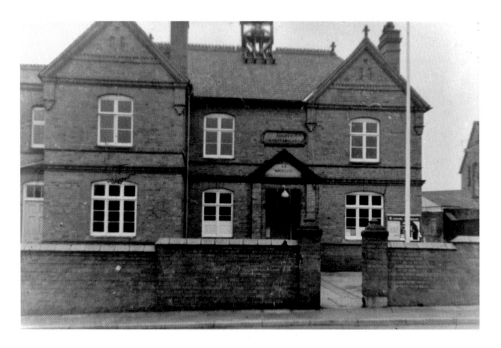

The Police Station 1960s/70s and 2010

The old photograph shows the police station that was built between 1860 and 1880 and replaced the one in Green Street which, like that police station, is long gone. This building was in the same design as other Cheshire Police Stations built after the foundation of the Cheshire Constabulary when it was formed on 20 April 1857; each one had a County Constabulary plaque on the front elevation. It was demolished in the 1970s and the new one built to replace it. I know which building was the most attractive and would have been better modernised than simply replaced with the ugly single-storey thing, especially now as Middlewich houses one of three Central Custody Suites in Cheshire.

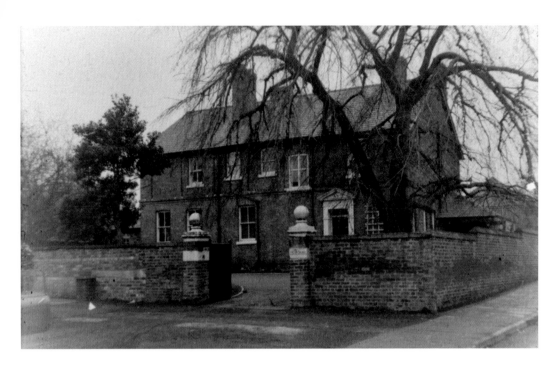

The Vicarage 1960s and 2010

The old photograph shows the vicarage in Queen Street which since the 1800s was the home of the vicar. It was once larger and the entrance was on the opposite side – what we are looking at is the original rear elevation. The vicar has now vacated the house and resides in a modern Rectory while this is a private residence.

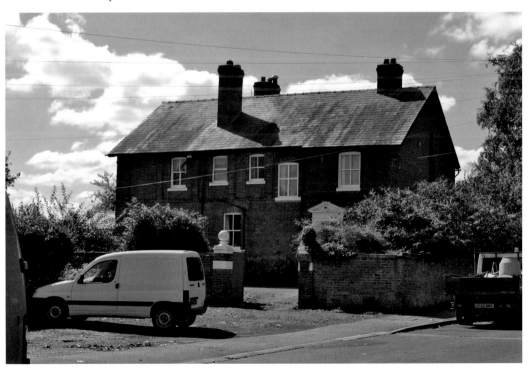

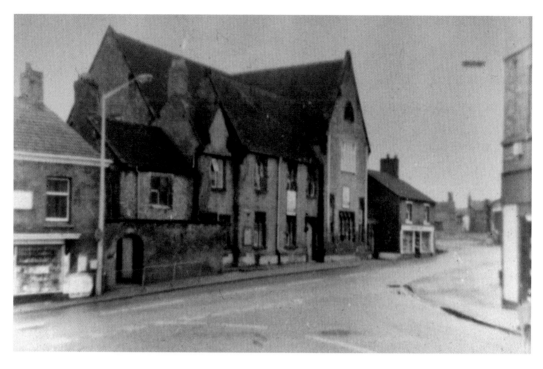

National School, Lewin Street 1960s and 2010
This school was built in 1854 as a Church of England school at a cost of £2,336.14 and extended in 1871. It soon became known as the National School and there was a house for the headmaster at the side. In 1860 this gentleman was Mr Frederick Bird and the mistress was Louisa Maria Groom, by 1936 Frank Lidbury was the master and Miss Murray and Miss Nuttall the mistresses.

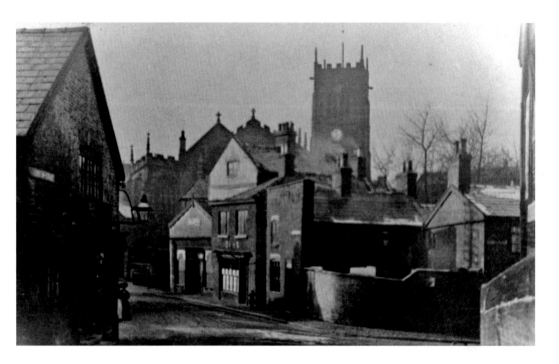

Leadsmithy Street 1900 and 2010
This well known old photograph is not of the best quality but it is included as it is ideal for this book. If you compare the old and new here you can see just how busy this area once was compared to today when it is simply a road towards the lights at the end of Lewin Street – although it is still called Leadsmithy Street here. This is where lead salt pans were once made for use in the many salt workings in the area.

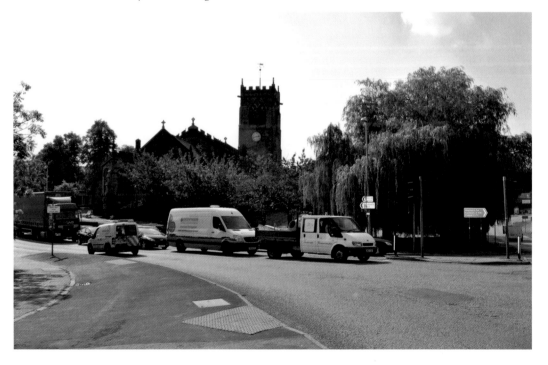

Wesleyan Methodist Church 1960s and 2010
The church seen in the old photograph from the side was further up Lewin Street from the National School and there was a shop between them. The first Wesleyan chapel was a small one in Pepper Street and then, in 1843, land was purchased in Lewin Street and a chapel built. This in turn was demolished around the turn of the last century and the one in the old photograph was erected. In 1973 this chapel was also demolished.

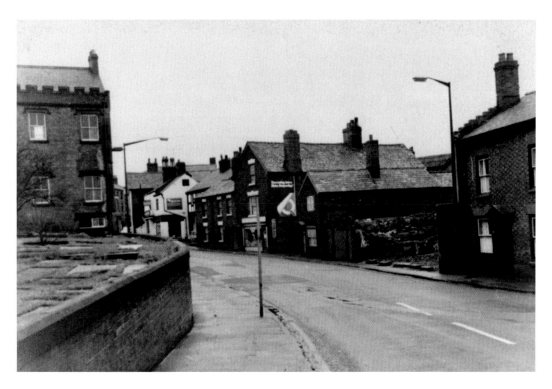

St Michael's Way 1960s/70s and 2010
Here we see an example of the demolition that took place to build the St Michael's Way partial dual carriageway through Middlewich in the early 1970s. Before this road was built all traffic had to pass up and down the narrow Wheelock Street, in the old photograph the Town Hall is still *in situ*.

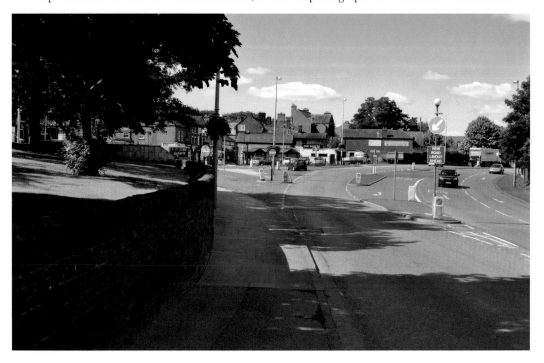

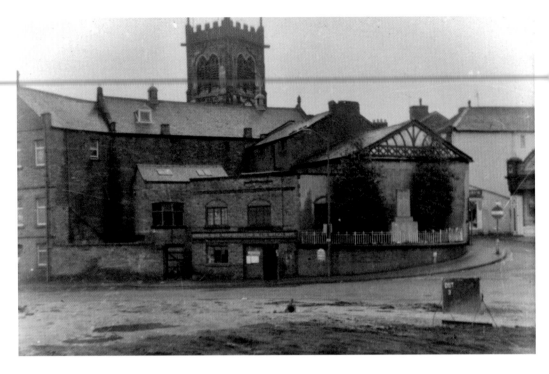

Towards the Bullring, 2010 and early 1970s
And here we see the church and its surrounding buildings just before the demolition started in the early 1970s. The workmen's signs are up and the area that the 1970s cameraman stood on has already been cleared of the buildings shown on the last page.

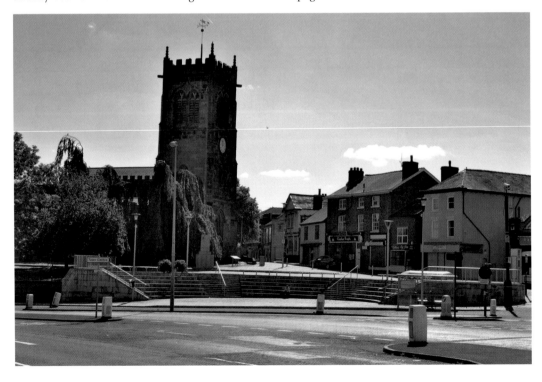

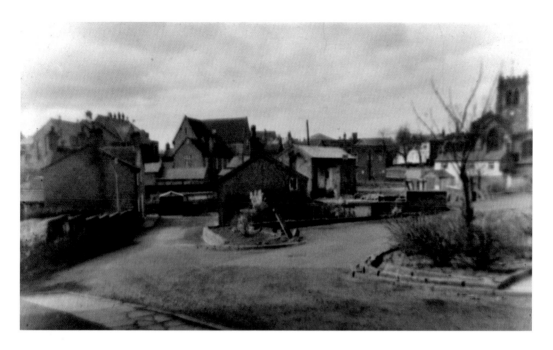

Church from Sea Bank 2010 and 1960s

Here we have a view from outside the Boars Head Hotel across Leadsmithy Street towards the church. The strangely named Sea Bank can be seen in the old photograph and just behind the Boars Head sign in the new. I can only think that the name Sea Bank came from the days of the canal when boats travelled to the sea. Someone may know differently? In the modern view trees and shrubbery have concealed the other side of the canal and in the old photograph the rear of the National School can be seen.

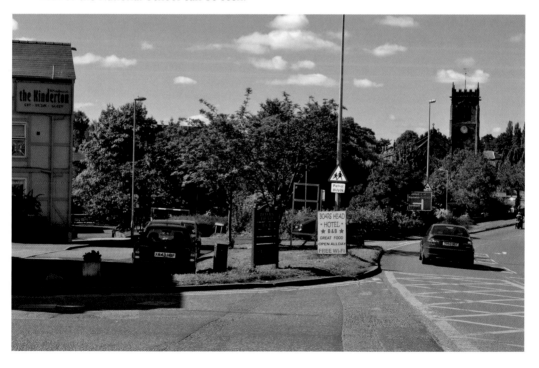

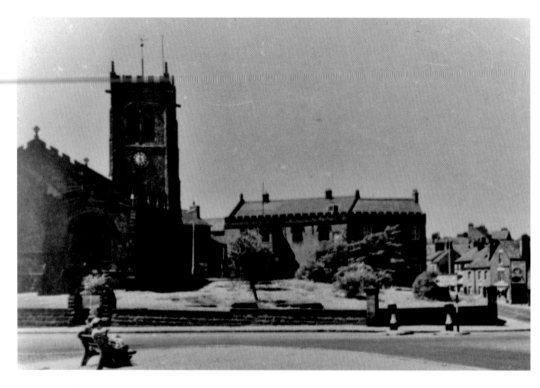

Church and Town Hall 1960s and 2010
Another look from across Leadsmithy Street, the canal, and the River Croco at the church and an excellent comparison shot before the new carriageway was built.

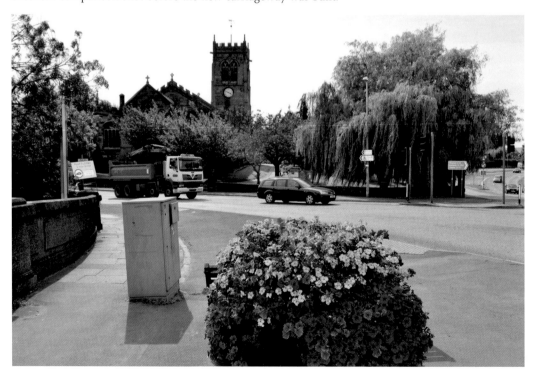

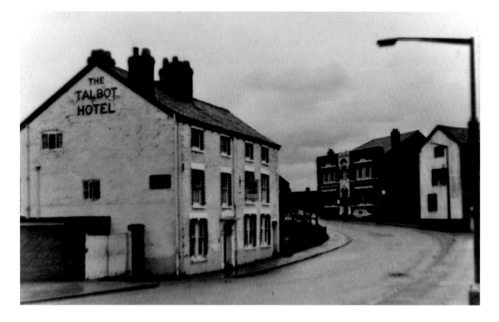

Site of the Talbot Hotel 1960s and 2010

The Talbot Hotel stood almost opposite the Boars Head as can be seen in the two photographs. It was demolished in the 1960s when the road was widened. This is the part of Middlewich known as Kinderton or Kinderton-cum-Hulme and was once a township in its own right. The Venable family were Barons of Kinderton for many years, Peter being the last of the line died in 1679 when the estate passed to the Earl of Abingdon. The estate eventually passed to Mr Henry Vernon Esq. who upon being raised to the peerage became Baron Vernon of Kinderton on the 12 May 1762. The family crest incorporated a boar's head. Hence the name of the pub and the boar's head figure on the front elevation. Kinderton Old Hall stood near to the pub and was demolished in 1924. The Boars Head is now a hotel and next door is The Kinderton Hotel. The road they stand in is still Kinderton Street.

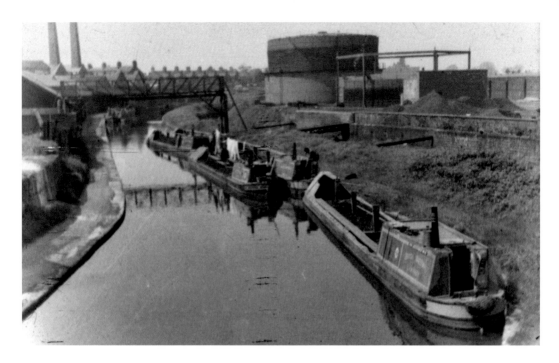

From the Town Bridge 1950s and 2010

In this set of photographs we look over the Town Bridge at the canal as it meanders towards Northwich. In the old photograph we see that even in the 1950s the area was a hive of activity with Seddon's salt works in Pepper Street on the left stretching away to the Big Lock public house. On the right is the gas works and the canal boats seen there are post nationalisation ones with the British Waterways logo and the blue and yellow corporate paint scheme. One wonders if privatising the canal carriers was ever a good idea and the romance was taken away with the corporate image. Canal-carrying as a business didn't last very long either way.

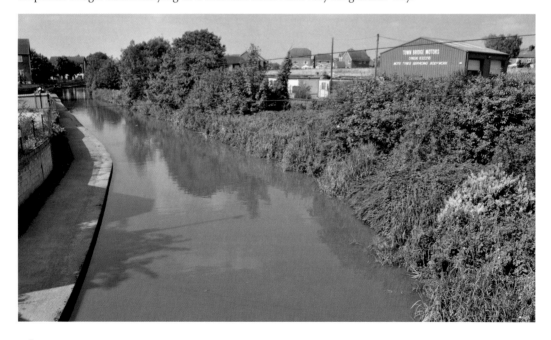

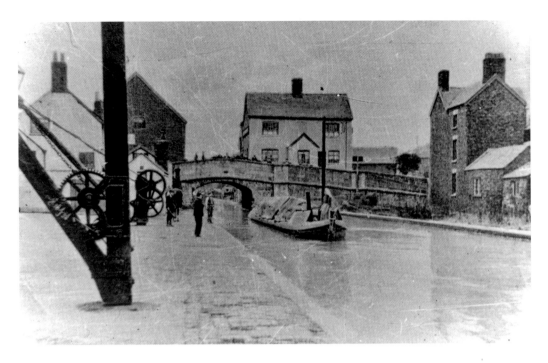

Old Town Bridge and Wharf 1920 and 2010

Despite the apparent lack of business when the old photograph was taken, this area was an important port on the Trent & Mersey canal. The Town Bridge which is seen in the old photograph was built in the eighteenth century but a bridge had been here since the fourteenth. It carried Kinderton Street across the canal and across the River Croco that ran parallel with it. The building almost on the bridge was the Navigation Inn named after canal navigation. The bridge was demolished during the road widening of 1930 when the new one that can be seen in the new photograph was built and opened on the 16th of December 1931.

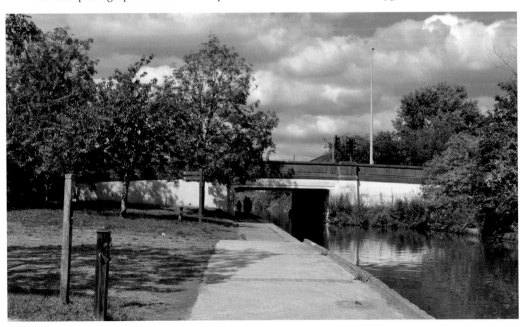

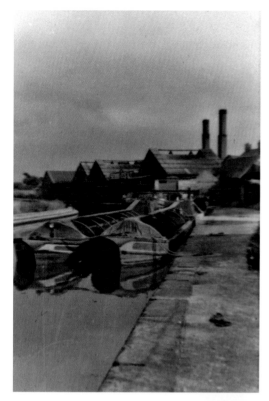

Approaching Town Bridge from Big Lock
Undated and 2010
We now walk along the tow path from the
Big Lock pub and pass what used to be
Seddon's Salt works on the right. The old
photograph was taken in the 1940s or 1950s
and shows canal boats loaded with what
looks like coal or coke. They have probably
arrived to re-supply the stocks for the fires
beneath salt boiling pans.

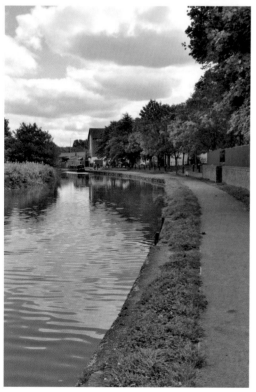

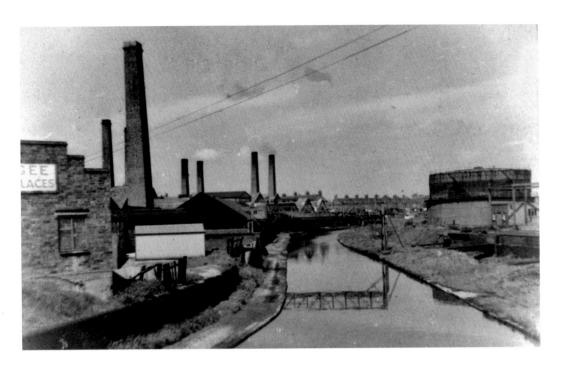

Canal towards the Big Lock 2010 and 1950s/60s
A last look at the view from the town bridge and the changes that have evolved over the years, what were once salt workings is now residential properties. Both the Pepper Street Works and the gas works opposite were demolished in the mid 1970s. David Griffiths one of the contributors remembers being taken to the gas works with his brother when he was four or five years old as they had whooping cough. Breathing in the fumes was supposed to help!

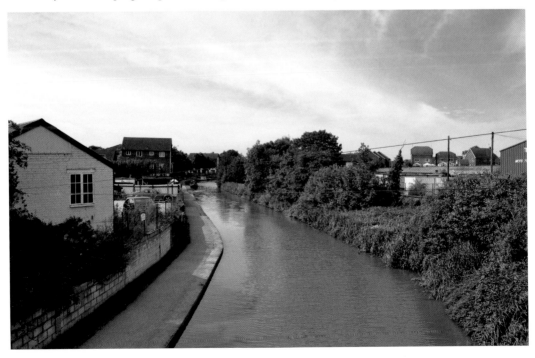

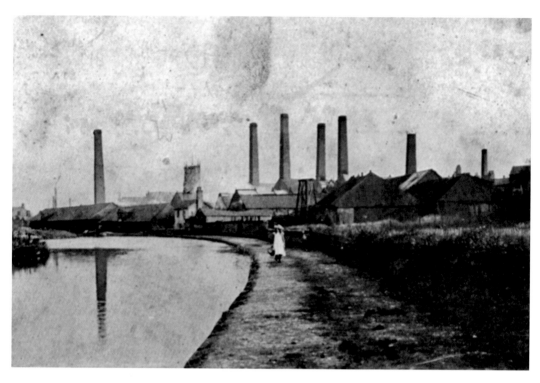

Site of Seddon's Salt Works 1900 and 2010
A last look at this stretch of canal from the Big Lock, in the old photograph the young girl is carrying a bag. Could this be the lunch that her father awaits as he works at the salt pans?

Big Lock Undated and 2010

We now reach the Big Lock pub which is at the side of the lock after which it is named, an important pub on the canal network it was built with openings onto both the canal and the street above. Originally it was built to a good standard upstairs with a basic bar for the 'scruffier' canal people at canal level. It has now been tastefully modernised inside and out and presents a very attractive view for the people passing through the lock.

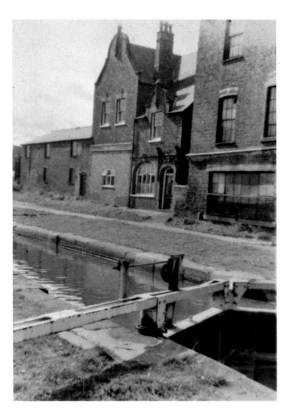

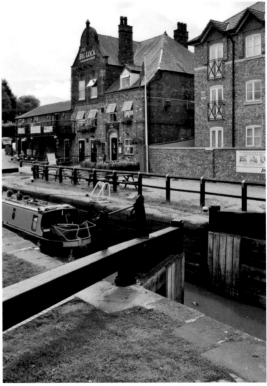

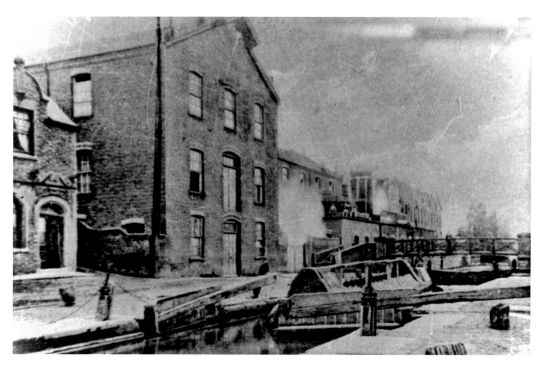

Big Lock and Factory early 1900s and 2010
A view of the pub from the opposite side and now in the old photograph the end of the Condensed Milk Factory can be seen, we will see more of it later.

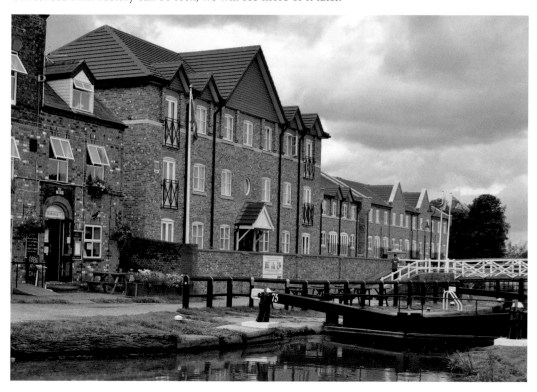

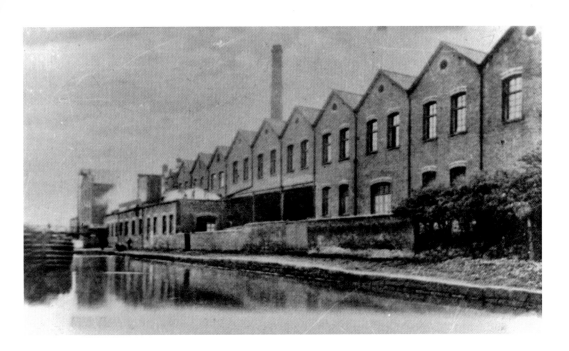

Condensed Milk Factory Undated and 2010
Now a look back towards the Big Lock and the large condensed milk factory alongside it, this was opened in 1872 by the Nestlé Anglo-Swiss Condensed Milk Company and during the summer months employed around 100 people. Two hundred cases containing four dozen cans of condensed milk were produced daily. In 1934 the manager was Thomas Haddon and the company officers were at 10 Mark Lane, London and 34 South John Street, Liverpool. As can be seen in the modern photograph, it has been completely redeveloped.

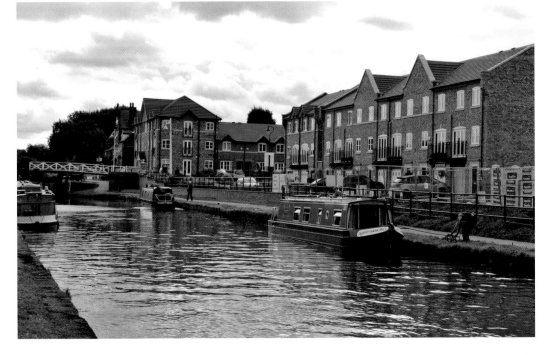

From the Railway Bridge 1960s and 2010

In these photographs the photographer has stood with his back to the bridge over the railway looking down Kinderton Street with the opening into King Street on the right. This was before the road widening for the lead in to St Michael's Way on what is the busy A54. Little has altered on the left side of the road and the two hotels can be clearly seen and the building with the 'phone box outside has been demolished and replaced with a very useful discount store.

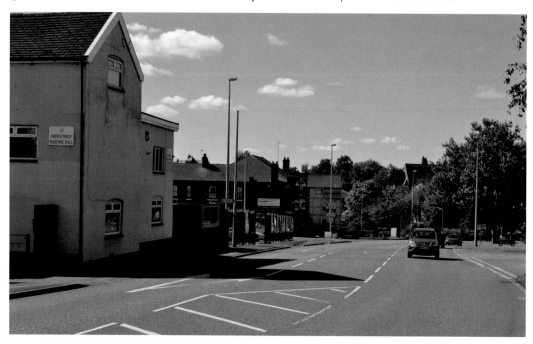

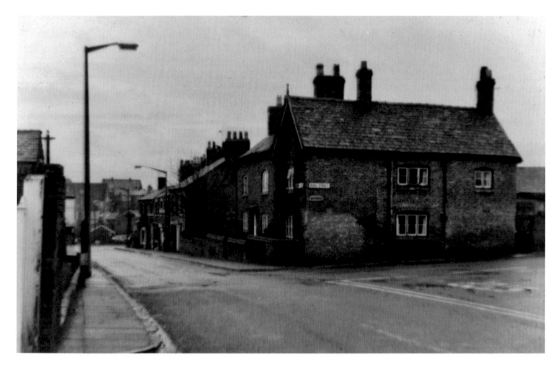

Junction with King Street/Kinderton Street 1960s and 2010
Looking now from the same vantage point as the last pair of photographs we look across the road towards the junction with King Street. The old photograph shows the buildings that were soon to be demolished as seen in the modern one.

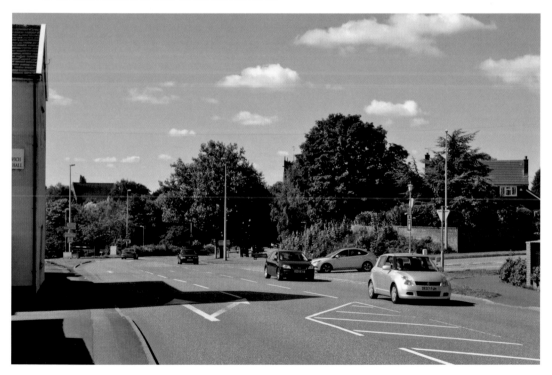

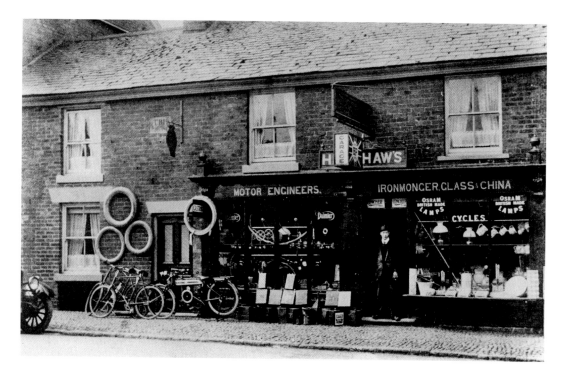

Henshaw's 1920/30 and 2010

Another old business but one that has now gone can be seen in the old photograph. Henshaw's was situated opposite the church. Motorcycles, bikes and cars were catered for as well as the old style ironmonger, glazier and china supplies. This was a long standing family firm; in 1860 Joseph Henshaw was a blacksmith and manufacturer of agricultural equipment. By 1934 Albert Henshaw had become a motor car proprieter, now as the new photograph shows, the shops have been split up and the larger of the two is for let at the time of writing.

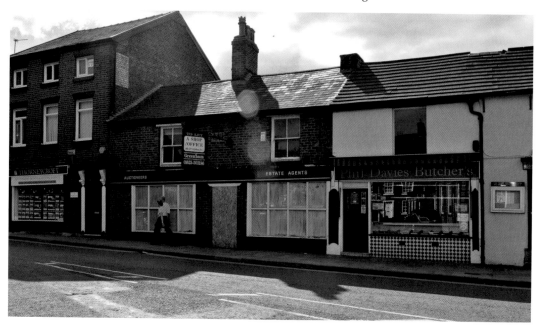

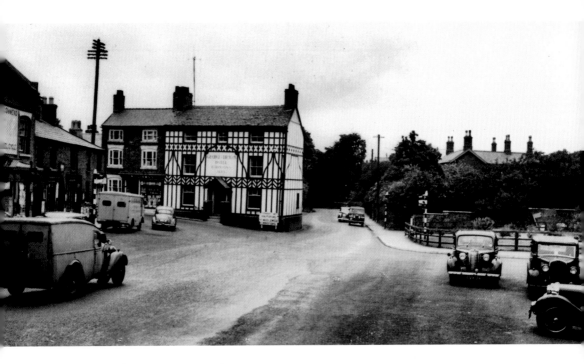

Holmes Chapel Square 1950s and 2010

This is an excellent photograph for those who want to see the old Holmes Chapel and the 1950s photograph was taken before the road widening. The old black and white George and Dragon pub is situated well forward of the present pub of the same name, with Williams' store next door. These buildings left a narrow Middlewich Road which is, as now, on the left. After the buildings at the end of Middlewich Road had been demolished the road was widened and a new pub built further back. What an eclectic mix of motor transport is on view.

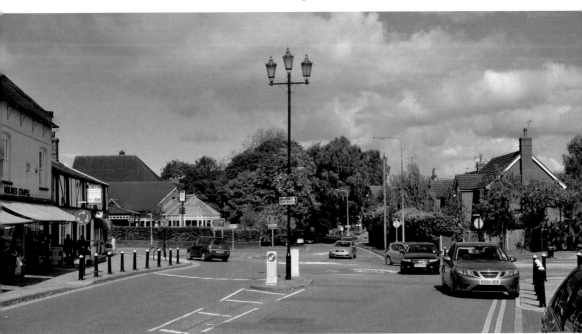

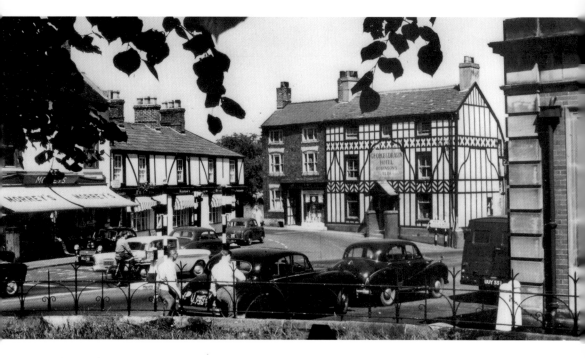

Holmes Chapel Square early 1960s and 2010

Another look at this old public house at a later date and the traffic has increased. Morrey's store is hidden by the church notice-board but is still there today, another longstanding Holmes Chapel company. The company was established in 1850 and in 1860 Thomas Morrey was listed as a cooper. On that date the address was The Village; then in 1902 a general dealer, cycle dealer and ironmongers. The black and white building on the corner is now the re-located Williams' delicatessen.

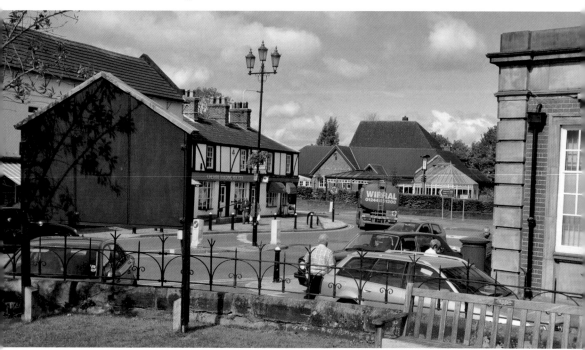

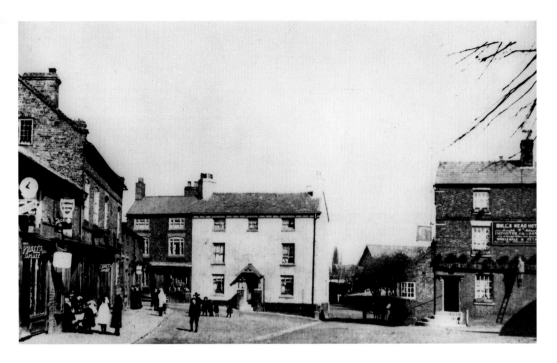

Holmes Chapel Square early 1900s and 2010

Here we have a last look at The Square back at the turn of the last century, the George and Dragon does not yet have its black and white façade and the Bulls head on the opposite side of the road can clearly be seen. In 1902 Johnson Joseph Whitney was the licensee and this pub housed both US servicemen and Italian prisoners during the last war, before being demolished in 1948 for the first attempt at road widening. Morrey's can be seen clearer in the new photograph but in the old one a name cannot be seen but adverts for Pratt's Spirit are there.

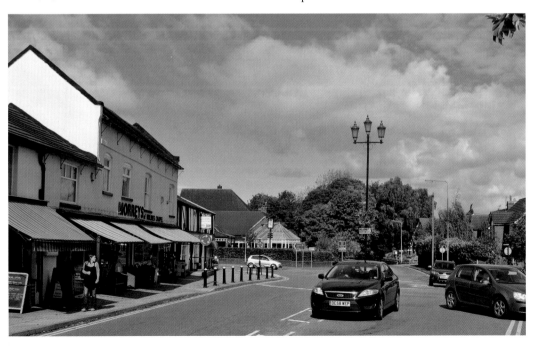

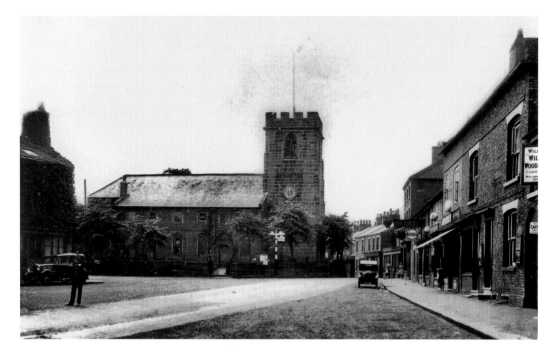

Holmes Chapel Square 1920s/30s and 2010

We now have a look into the square from the opposite direction and towards the church, I cannot think who the policeman is signalling to, he is probably posing for the photographer. This has always been an important crossroads though; straight on here is to Congleton and the south. Behind the photographer are the roads to Knutsford and the north and Chester and Macclesfield to the east and west. The church of St Luke dates from the middle Ages and was once half timbered with an oak beamed roof. This can still be seen but the building was renovated in 1700, with bad wood removed to be replaced with red brick. This saved the church in the great fire of 1753.

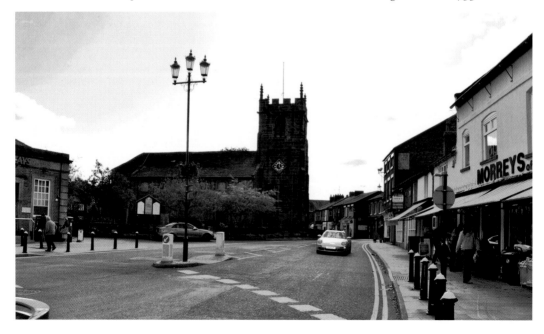

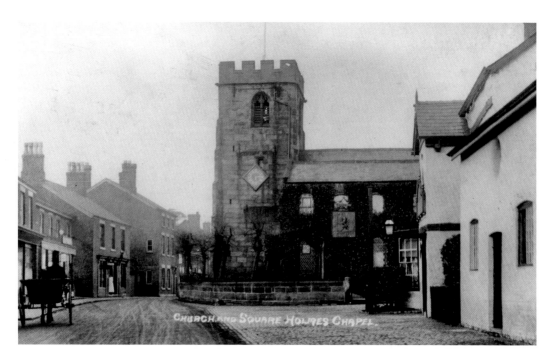

Church Square early 1900s and 2010

We now follow the church wall that extends into the busy road arriving at the Red Lion pub on the right with cobblestones at the front. The driver of the pony and trap enjoys the view as the horse plods towards the crossroads. The modern photograph shows just how busy the road is now. The George and Dragon licensee changed the name of his pub from the George to the New Red Lion for a while in 1752 presumably to pinch some business from the more popular Red Lion!

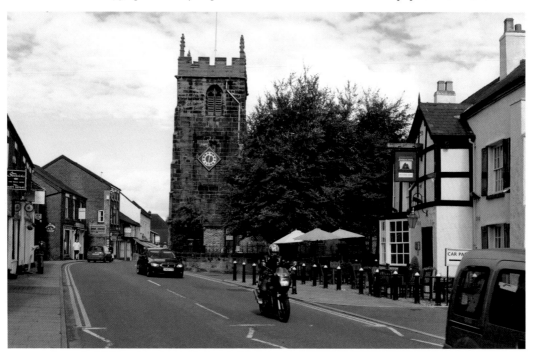

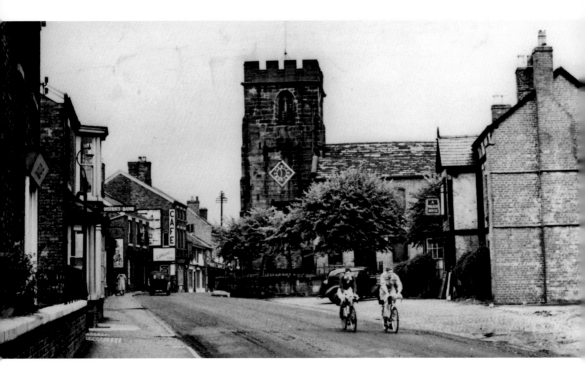

Church Square 1940s/50s and 2010

A more modern look at the same scene and we see that little has changed over the intervening fifty years. What more can be said here, the photographs speak for themselves!

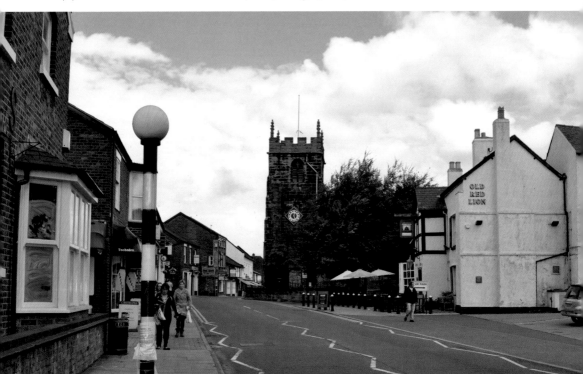

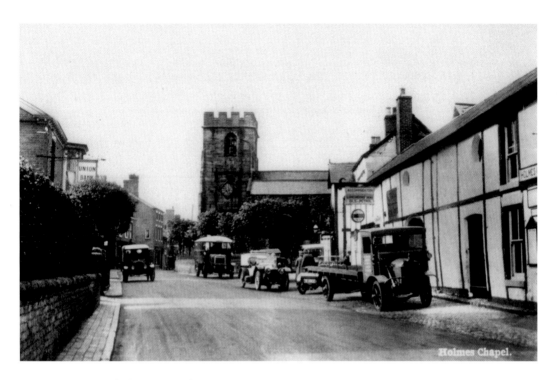

Red Lion and Church 1910/20 and 2010

What a superb period photograph this is, dating from the early part of the last century. There is private traffic, business transport and an omnibus. At this time the inn advertised accommodation, luncheon and oil. The building that the lorry stands outside was the old stables for this coaching inn; they have now gone and have been replaced with a car park.

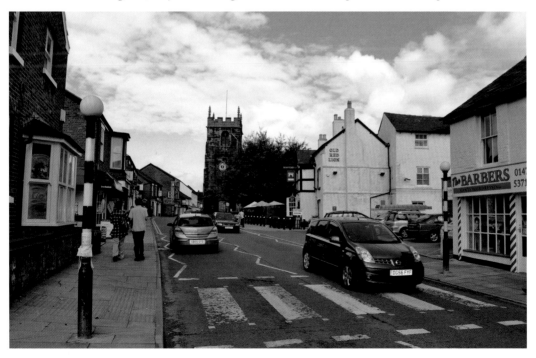

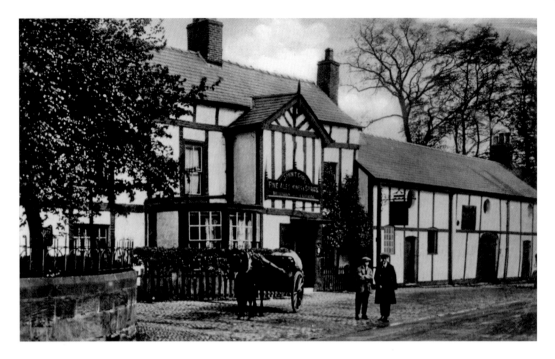

The Red Lion late 1800s and 2010

This ancient inn is now known as The Old Red Lion with good cause, as it dates from at least as far back as the 1600s, and was an important inn on this busy road. Retainers of Bonnie Prince Charlie stayed here and scratched on a windowsill: 'Bless and preserve Prince Charles for ever, Amen, I pray God'. Even Charles Wesley is reported to have preached there in 1738 and when a great fire destroyed Holmes Chapel on 10 July 1753, only the Red Lion, the church, and two cottages behind it were saved.

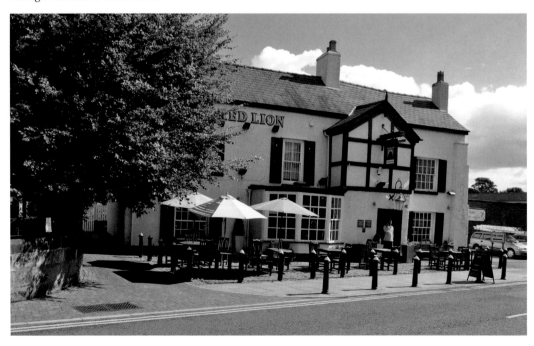

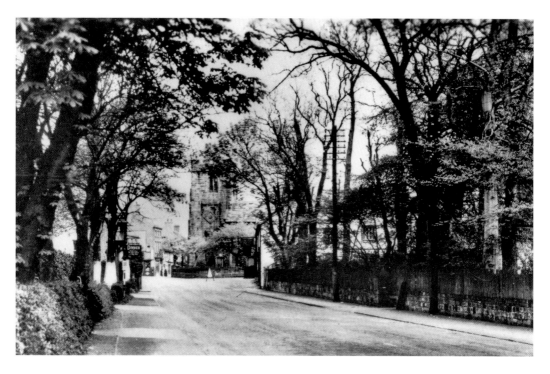

Shopping Centre Site Undated and 2010

The old photograph is taken of the area that went to build the new shopping centre and looks back towards the church. The new photograph shows the access road to the shopping centre on the right.

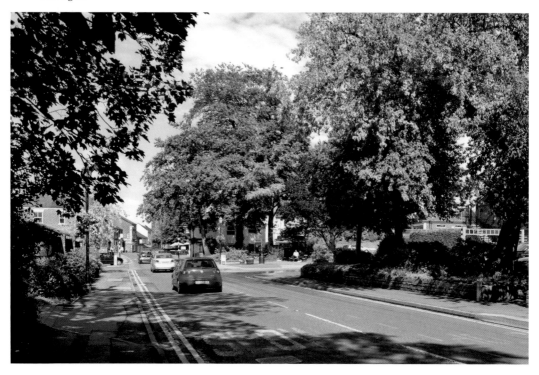

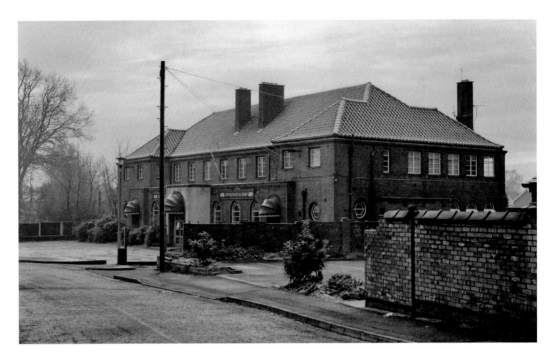

The Good Companions 1970 and 2010

This large public house was built in 1937, as the roads between Manchester, Liverpool and London passing through Holmes Chapel became very busy before the motorways. As the years passed by it became popular as a Berni Inn eatery but the downturn in public house use that accompanied the new millennium took its toll and like many similar establishments throughout Britain it was closed. This was one of the earlier ones being demolished in 2001 and re-developed as retirement flats.

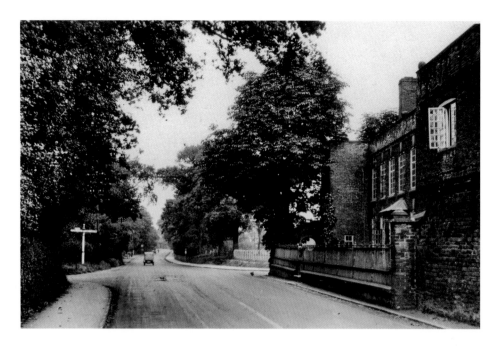

Four Lane Ends 1920s and 2010

This is the second of two crossroads in Holmes Chapel and it has been known as Four Lane Ends for many years. The large house on the right is Lane Ends House built 1680–1700 and was demolished in 1939. In 1860 it was the home of Revd Charles Hodges vicar of Byley. In 1918 Major Thomas Clayton Toler purchased the house from his cousin and lived there until 1930 when he moved to Swettenham Hall. His son David Arthur Hodges Toler was born in Holmes Chapel in 1920; Commissioned into the Coldstream Guards in 1941 he went on to become a war hero and holder of the MC and the OBE. As a Major General he was the first Commander Land Forces in Northern Ireland in 1969. He died on the 19 November 2009 at the age of 89.

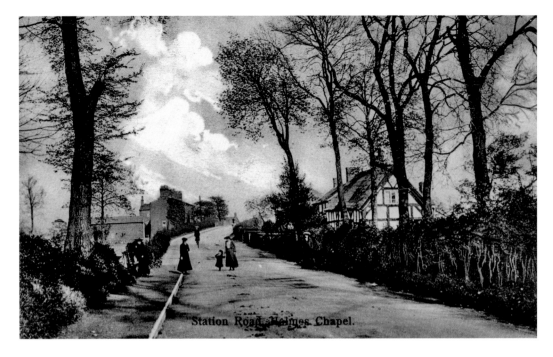

Station Road 1905 and 2010

This road leads from Four Lane Ends to Congleton, here approaching the railway bridge by Holmes Chapel Station and the Swan Hotel. The railway was opened by the Manchester and Birmingham Railway Company in 1841 and later extended to Crewe; it was originally crossed with a level crossing, soon to be replaced with a bridge. Strangely the station hotel built around the same time was not called The Station Hotel, as was popular, but The Swan. Later when the Swan Inn closed in Knutsford Road it acquired the name and added Inn to its title.

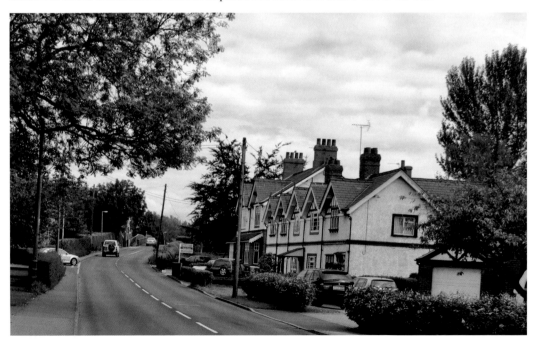

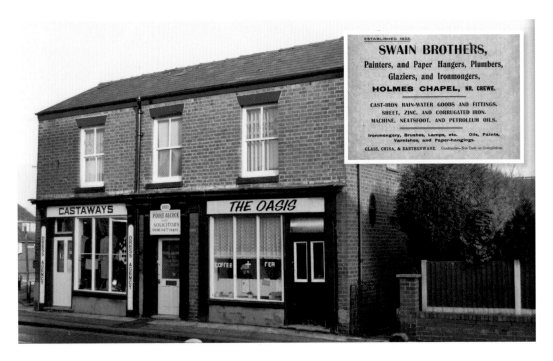

ESTABLISHED 1832.

SWAIN BROTHERS,

Painters, and Paper Hangers, Plumbers,
Glaziers, and Ironmongers,

HOLMES CHAPEL, NR. CREWE.

CAST-IRON RAIN-WATER GOODS AND FITTINGS.
SHEET, ZINC, AND CORRUGATED IRON.
MACHINE, NEATSFOOT, AND PETROLEUM OILS.

Ironmongery, Brushes, Lamps, etc.　Oils, Paints,
Varnishes, and Paper-hangings.

GLASS, CHINA, & EARTHENWARE.　Contracts—Net Cash on Completion.

Cinnamon Lodge 1970s and 2010

This building is at the start of Macclesfield Road opposite Mandeville's and in 1860 was the shop premises of Samuel Swain, plumbers and glaziers. The shop was opened by Thomas Swain in 1832 and then remained in the family for 150+ years, selling petrol at the dawn of the internal combustion engine in the late 1800s. In 1936 Samuel Swain traded as a plumber and Mrs Emma Hatton Swain was a draper in the village. By the 1970s it was three businesses, a café, dress agency and solicitors' office. As can be seen from the modern photograph the building now houses the Cinnamon Lounge Indian Restaurant.

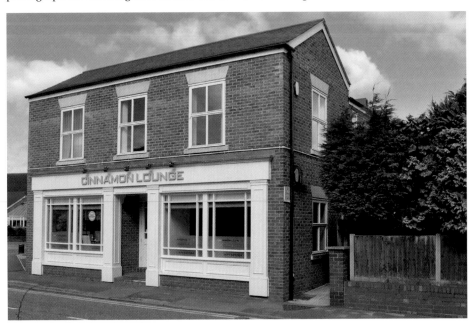

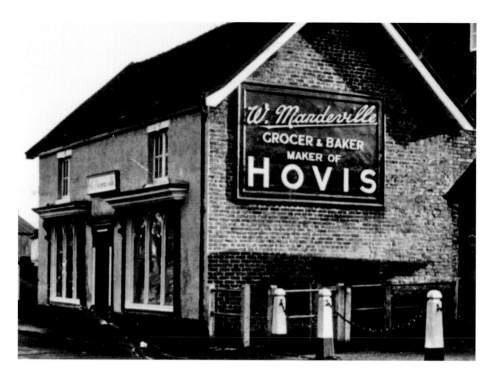

Mandeville Shop Undated and 2010

Here we have another of Holmes Chapel's excellent and long standing family firms, which was started in 1900 by Joseph William Mandeville – in 1925 his son William took over. In 1937 'Fertility Bread' was patented by William. It was said to make childless wives fertile and was famous across the world until the start of the Second World War. In 1956 William Mandeville's eldest daughter Delia married Geoffrey Wakefield and they later became partners in the business, becoming proprietors on the death of William. This delightful bakery, confectioners and delicatessen is now run by their son Simon Mandeville Wakefield and its Geoffrey that I have to thank for the majority of Holmes Chapel old photographs in this book.

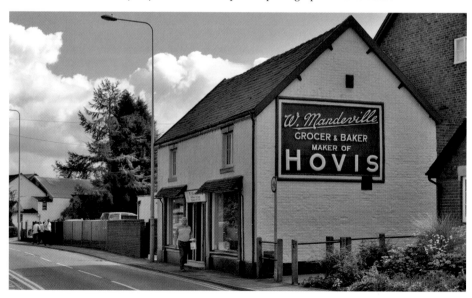

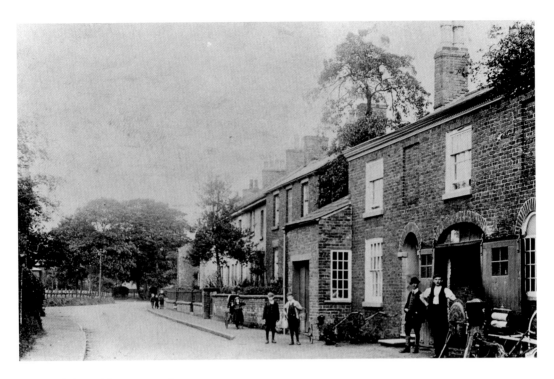

Dale's Smithy 1900 and 2010

We now walk further into Macclesfield Road and come to Sam Dale Agricultural Engineers. This forge was established around 1840 by the Henshaw family who remained there until the turn of the century as it was handed down through the generations. It was then worked as a forge by other blacksmiths until 1927 when it again became a family concern as it was purchased by Sam Dale whose family still run the business. As you can see, there have been some alterations to the front but the now bricked up arch can be seen.

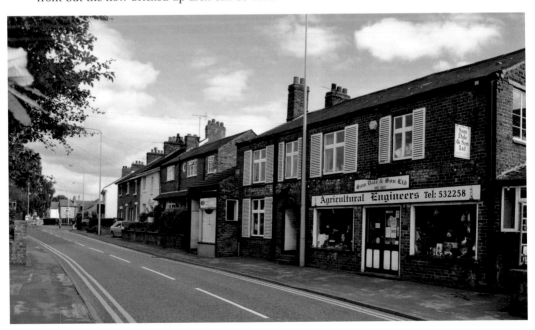

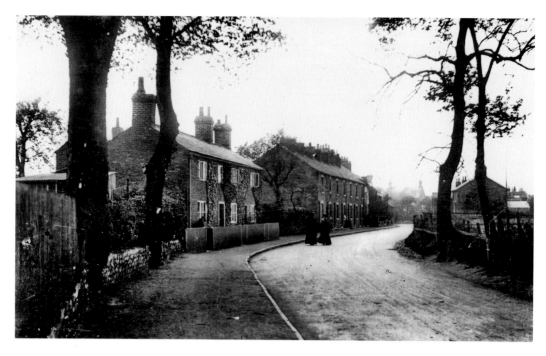

Macclesfield Road 1900 and 2010

Looking back now towards the village centre we see a much altered house. In the old photograph ladies in their period dress walk leisurely along the road without much worry. No heavy wagon could scoop them up then as would be likely today.

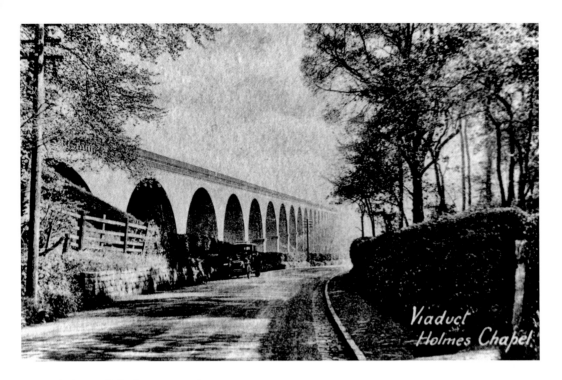

Viaduct Hill Early 1900s and 2010

Still on Macclesfield Road we travel out from the village down a hill which in turn takes us to a series of bends and then towards the famous Jodrell Bank. Here we start to pass the Holmes Chapel railway viaduct, not perhaps as high as the one in Stockport but certainly longer. The period car has stopped on what is now a very busy road.

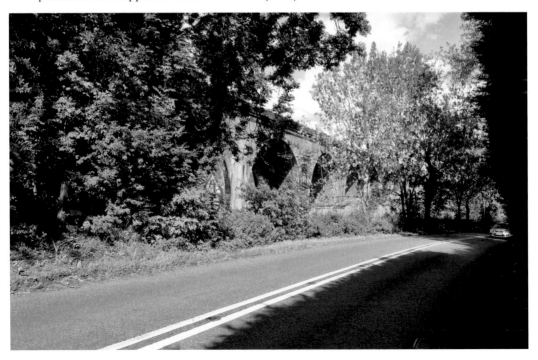

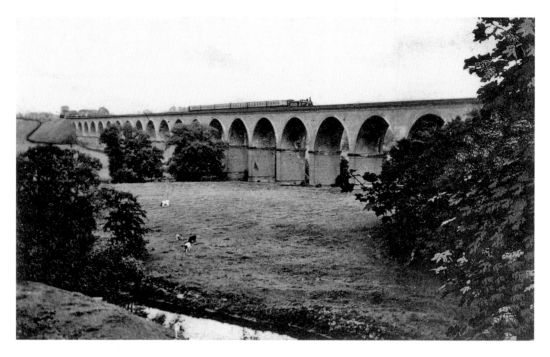

Viaduct Holmes Chapel early 1900s and 2010

Here we get a view of the full viaduct in all its glory, 23 brick arches each of 63 feet span giving it a total length of 1,794 feet. It was built to carry the railway across the Dane valley, a railway that once meant steam traction but now means the ubiquitous Pendolinos and railcar units. It was built around 1840 by about 500 navvies using the most primitive equipment on what is very marshy ground. It was opened in 1842.

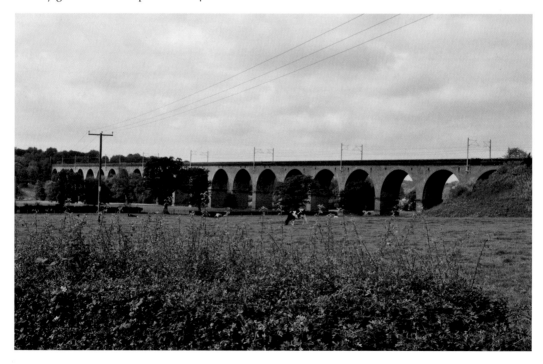

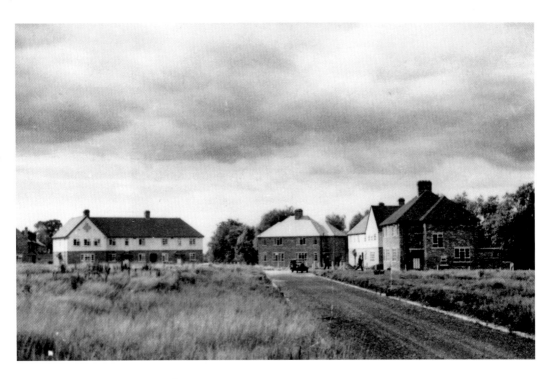

Housing Estate 1953 and 2010
Here we see an example of a well built and attractive estate in 1953; it shows West Way off Chester Road. In the 1953 photograph the estate is under construction with only a small number of houses completed.

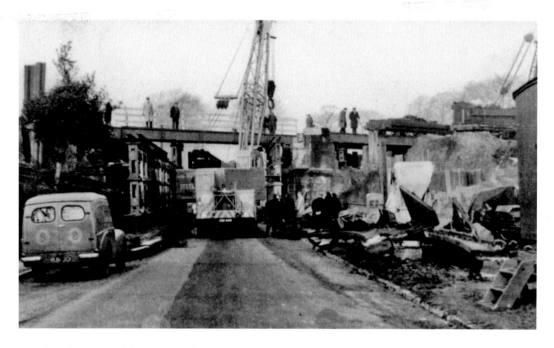

Building the Iron Bridge 2010 and 1952

We conclude this look at Holmes Chapel by travelling down London Road to the Iron Bridge. This bridge which carries the railway over the road was originally a cast iron curved arch bridge. As traffic became heavier, and with high sided vehicles, it became necessary to restrict passage through it to the centre of the road using a chicane. Needless to say it was eventually damaged and this could not go on so, in 1952, a new bridge was built to take traffic in both directions and the road was lowered to enable even higher vehicles. The view in the modern photograph is towards the village taken from outside the now unused Bengers Food Factory.

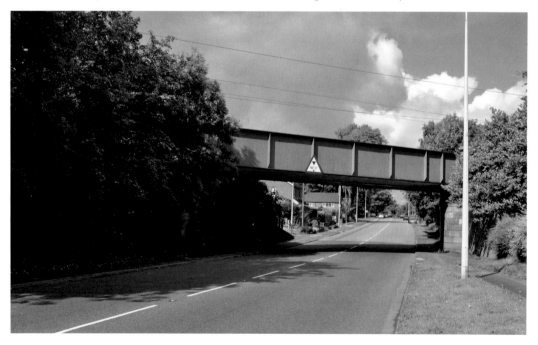